PATCH WORK

PATCH WORK

A Life Amongst Clothes

Claire Wilcox

BLOOMSBURY PUBLISHING
LONDON · OXFORD · NEW YORK · NEW DELHI · SYDNEY

BLOOMSBURY PUBLISHING
Bloomsbury Publishing Plc
50 Bedford Square, London, WC1B 3DP, UK

BLOOMSBURY, BLOOMSBURY PUBLISHING and the Diana logo
are trademarks of Bloomsbury Publishing Plc

First published in Great Britain 2020

Cover image captured from the V&A collection

A catalogue record for this book is available from the British Library

ISBN: HB: 978-1-5266-1439-1; eBook: 978-1-5266-1438-4

2 4 6 8 10 9 7 5 3 1

Typeset by Libanus Press Ltd
Printed and bound in Great Britain by
CPI Group (UK) Ltd, Croydon CR0 4YY

To find out more about our authors and books visit
www.bloomsbury.com and sign up for our newsletters

CONTENTS

One PRELUDE 1
Kid Gloves 3

Two BEGINNING 9
Night Clothes 11
The Airing Cupboard 15
The Apron 17
Sheets 19

Three BRINK 21
Ribbon 23
Bias 25
Yellow Pages 27
The Silk Road 29

Four VERDANT 33
Forsythia 35
Hair 37
Seeing 39
Kimono 43
Tapestry 45
Purple Velvet 47

Five STOREROOM 51
 Mail Order 53
 Thread-counter 55
 The Skirt 57
 Ladder 61

Six CATCH 67
 The Cat 69
 Keeper 71
 Silver Thread 73

Seven UNBOUND 77
 Life Model 79
 The Cot Quilt 81
 Counterpane 83

Eight ENTWINED 87
 Lustre 89
 Hourglass 91
 Bound 95

Nine LOVE 99
 Island 101
 Overdressed 105
 Flannel 107
 Fairy Wings 109

Ten GATHER 113
 Tight Socks 115
 Red Shoes 117
 The Gown 119
 Arrangement 121
 Conditioned 123

Eleven SENSATE 125
 Touched 127
 Mimesis 129
 Fashioned 131

Twelve CURATOR 135
 Wadding 137
 Production Line 141
 Apple Pie 145
 Foil 147
 Too Late 151

Thirteen SEAM 155
 The Pram 157
 Dressmaking 159
 Wedding Suit 163
 The West Wind 165

Fourteen LOSS 169
 Emails 171
 Recovered 173
 Canvas 175
 The Runner 177

Fifteen	DUSK	179
	Foot-sure	181
	Imprint	183
	Overcast	189
	Gothic	191

Sixteen	IMMERSION	195
	Lost	197
	Watermark	199
	Tide	201
	Memory Foam	203

Seventeen	MIST	205
	Lungs	207
	The Watcher	209
	Harbour	213

Eighteen	ARCHIVE	217
	Investment	219
	Elysium	221
	Confined	223

Nineteen	HOME	227
	Drip-dry	229
	Intact	233
	The Museum	235
	Slippage	237

Twenty	VERTIGO	239
	The Clothes Moth	241
	Dust	243
	Safety Curtain	245
	Margin	247
Twenty-one	NOCTURNE	251
	Red Gloves	253
	Weeds	255
	The Committee of Rearrangement	257
	Draw the Curtains	261
	Acknowledgements	267

One · PRELUDE

KID GLOVES

In the dim storeroom we laid the dresses on beds of tissue and placed them in shallow wooden drawers. The drawers sat inside mahogany cupboards that reached up to the ceiling; each had a metal holder and card identifying it by number. There were hundreds. Some of the doors were warped, and we had to lean in hard to close them. The locks were old-fashioned too and we were forever dropping the heavy brass keys onto the tiled floor as we fumbled trying to turn them in their fixtures. The museum was not built for storage, but for the display of exhibits from the *Great Exhibition of the Works of Industry of All Nations* in 1851. Its fashion included ribbons from Coventry, silks from Lyons, footwear from Nottingham and shawls from India. Ever since then, the museum has accrued and garnered, harvested and gleaned, its walls creaking and straining with the mass of history.

Clutter has built up on the tables. We try to keep them clear in order to perform inspections of the curatorial kind. We draw out the velvet wings of an opera cloak bought from Liberty & Co. over a century ago. We spread out a lace veil, slowly disentangling its soft barbs, and cautiously unfurl a parasol, releasing a faint puff of perfume. We are fighting for space with stacks of trays full of objects waiting to be studied, or photographed, or put on display. A framed medieval chasuble leans

against the table, draped with white tissue paper like a badly wrapped present. It was put there several years ago, until somewhere better could be found. We will get around to moving it one day.

We were choosing dresses and accessories for the permanent display. Permanent and temporary are words we use to describe gallery displays and exhibitions, although rarely in their true sense. Permanent can mean anything from a decade to a lifetime, while temporary, in museum time, often goes on for years. When we acquire, we say it is *in perpetuity*, like a sacred bond between building and object, holder and held. So it is on one level. Sorted, categorised, catalogued, numbered, the collective collections represent the gathering together of excellence; of history, taste and skill. We are caring for high-quality detritus of the past in order to understand who we are.

We employ the term 'objects' because it covers everything, large or small, modest or spectacular, and because it is distant and professional; respectful. We treat the objects with kid gloves, avoiding sudden movement, and think through the steps we take from cupboard to table as, for example, we airlift a massive crinoline weak with age. We settle its folds, form rolls of tissue to support its boned struts, and pass our hands over the creases like mediums intent on resurrecting the dead. We make our notes in pencil (pens are forbidden), observing every detail, counting every button, notating every anomaly, inside and out. It is called a condition report.

Our language is frequently of devastation and disintegration. We talk of *shattered* silks – when the brittle fabric splits, often down an old crease; *fugitive* dyes that have faded through time, leaving behind a curiously unbalanced palette where blues become green and reds become brown. We notice signs

of *erosion*, where a fabric has rubbed against a stronger element such as a metal buckle, and isolate *perished* objects that reek of chemical degradation (we have a collection of mackintoshes with rigor mortis). We remove *tired* pieces from display, speaking of their need to rest. We undertake emergency measures against infestation (moth, carpet beetle and woolly bear), rush to the museum from our beds in the event of flood and enclose our objects in glass cabinets against malicious damage and theft, bright light and heat, damp and sudden chills.

Today, we are looking at printed cotton dresses from the 1830s. They are charming – the tiny patterns scattered over the fabric giving unity to the complex anatomy of the garment. The necklines are wide. For day, a soft cotton fichu would hide shoulder tip and collarbone, but for evening, such an unveiling of flesh would be perfectly acceptable. A whole infrastructure once held things in place. Puffed sleeves were held proud by down-filled pads tied onto the upper arm; full skirts were supported by ribbed and pleated petticoats, and a coiffure was laboriously bulked up with coils of others' hair. To provide a convincing display, we group things that have never been grouped, create a unified ensemble from clothes that have had multiple owners. We hold things up for scrutiny, try them out on a dressmaker's form. We become distracted by a never-worn green dress that we think might be a maternity gown.

We are composing a display case in our minds. We know how many mannequins it will take (three) and that we will have a number of tables at the front for smaller things – a straw bonnet, some fashion plates, a purse, a pair of kid gloves – satellites to the real stars of the show. We look inside the bags, although know they'll be empty; bags are such a mystery, they always arrive in the museum cleared out, as if absolved of personality. We are composing labels in our mind as we regard

the objects, and offer up thoughts for consideration, saying, *perhaps ... if we put this with this ...* Our curators' hands are there not just to handle and hold, but to gain tacit knowledge of our objects, to feel their history through stitch and thread.

We have decided to arrange the display chronologically. But it will always be a three-dimensional puzzle with the majority of pieces missing. We know that for each fretted, painted and beribboned fan in our possession, a million will have been lost, as they swirled around house clearances, vintage stores and salerooms, with only the best and rarest finding refuge in the museum, like exhausted migratory birds. Sadly, our fans won't be fluttered again, nor will a swelling belly fill the green dress. Corsets won't be strained to the limit, nor kid gloves distended with stretchers to receive the hand of a lady. But to look on the bright side, rough hands will never wash the clothes carelessly again, scorch them with an iron, remodel them, or rip them up for rags.

At one time, we wore surgical gloves to avoid inflicting further damage through sweat or the snagging of a thread on wedding ring. But these blotted our feelings and made us clumsy. Now, we revert to bare skin, accepting that we will leave particles of DNA like invisible calling cards. We trust the thousand sensors in our fingertips to authenticate and explore the dresses through touch: the tiny ridge where a dressmaker's pin has been left in a hem; the slightest textural change where a seam has been altered; the presence of dirt trapped in a cuff that will damage (for dirt particles are sharp); the weight of quality in a dress that spurs us on to keep searching for an haute couture label (often hidden in the folds to avoid export tax). Our selection of dresses for the permanent display (intended duration: seven years) has relied on touch as well as sight, for we have learnt much from the delicate kiss of fabric on skin.

Two · BEGINNING

NIGHT CLOTHES

The bedroom was large and square, like all the rooms in our house, and had white walls and a marble fireplace. The mouth of the fireplace was boarded up, but I took off the cover and burnt incense that left fragile coils of ash in the recess where the grate had once been. In-between the sash windows and the road was an ancient birch tree, its thick, bent trunk a silvery grey. The canopy of leaves fluttered and swayed and filled the room with greenness and flickering movement.

I had a single bed in the corner. It was covered with an Indian cotton bedspread from Kensington Market. I bought patchouli oil there too, and my mother thought it was the smell of drugs. I recorded John Peel's radio show onto cassettes, listening to his voice late into the night and sensing the music he played was a portal into my future life. When it rained, the passing sound of cars briefly woke me, and my desk and chair cast uneasy shadows in the dark and the piles of clothes on the floor looked like boulders. I copied *The force that through the green fuse drives the flower/Drives my green age; that blasts the roots of trees/Is my destroyer./And I am dumb to tell the crooked rose/My youth is bent by the same wintry fever* onto the wall in green ink, believing that my youth, too, was afflicted by a mysterious malaise.

Sometimes, when I was on the edge of sleep, I had the sensation of being anaesthetised. I wanted to pull back but couldn't stop the slide downwards into oblivion. Once, I had tonsillitis

and dreamt of a vast, empty road stretching before me. A wheel of some sorts was going along it; it wobbled, but just kept going. I was both on the wheel, of the wheel, and watching the wheel, as it wobbled, and just kept going down the middle of the road.

* * * *

The clothes of sleep have always interested me. I used to work in a shop that sold Victorian and Edwardian bedclothes, lace and lingerie. Nearly everything in the shop was white, and one of my jobs was to wash, starch and iron these things so that they looked new and smelt fresh, although they were old. The sheets were often linen, and responded magnificently to laundering, becoming heavy and silken, the quality of the material completely superior to anything available today. The lace-edged pillowcases crisped up and I liked burying my face in them, to smell the washing powder and the singeing of the iron. The nightdresses, petticoats and camisoles turned from yellowed and limp to a starched, pristine white. We put price tags on them and hung them on the rails and coveted them because they were so beautiful. Some, perhaps once part of a trousseau, had embroidered monograms and dates. I wondered who had owned them.

We wore nightdresses as shirts and petticoats as skirts, girdled our waists with silver nurses' belts, and felt very dashing – for foppish clothing was in fashion. Our style was vindicated by the fact that Grace Coddington, then fashion editor at British *Vogue*, often came into the shop. She borrowed some of our clothes to do a fashion shoot, featuring girls with tousled hair, wearing voluminous shirts and striped pyjama trousers, for we sold menswear too, soft, collarless shirts and thick nightshirts that came down to the floor. My brother was away at university,

and I sent him one; was surprised at his gratitude, hadn't known he was homesick and cold.

Men's sleepwear never seems to change. I think of my father wearing striped pyjamas as he sits in a hospital bed recovering from tuberculosis, smiling nurses either side. Striped pyjamas occur again, this time not in a black and white photograph, but in my memory. My father is sitting up in bed at home, just as he was in the hospital, reading a newspaper and shaking it to get the creases out. I am lying under the tent of bedclothes created by his knees. He is better. Soon after, we go on holiday, driving to a campsite in a green field. After he dies, I find an old slide. I stand in the field, looking at him, in my pyjamas. My mother has her arm raised, as a flock of gulls flies up around us, their blurred wings white against the sky.

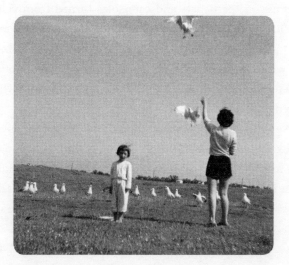

THE AIRING CUPBOARD

I help my brother into the airing cupboard and climb in after him, pulling the door closed so that it goes dark. We have to curl up, there is so little room. The shelves are made from slatted wood, and the folded sheets are smooth and warm under our legs. The boiler ticks and hums and we pretend to be asleep when they call.

I had been lying on my stomach playing a game, and he'd wanted to join in. You have to tell stories in your head, I said, through the leaves of grass. He didn't understand and wandered away. He was wearing his blue duffel coat and the puppy was snapping at his legs. When I got home from school it had gone to the country, where it would be happier.

I was reading in the armchair and wouldn't be disturbed. Next door came and went, and I didn't look up. I was allowed to go to the library on my own and read all the way home. A fire engine nearly ran me over and I got shouted at: *Four-eyes.* He didn't get on with books but liked comics. It's better than not reading at all, they said.

I was leaving home. I told him about my records and which ones he had to listen to. When I came back, he was taller and his fringe didn't tangle in his eyelashes like it used to. He seemed to be all right, although it wouldn't have occurred to me to ask. We didn't talk about things like that.

THE APRON

The telephone was in the hall by the front door, and when we answered it we copied the rising tone of the grown-ups. It would usually be one of the uncles. They were always moving back in and out of my Welsh grandmother's house, even after they were married. It was an end of terrace with a tiny kitchen extension, and despite the lack of space the front room with its china cabinet and unlit gas fire was rarely used. The living room was where everyone wanted to be and was taken up with arm-chairs and a table pushed against the wall where the uncles shouted and played cards and ate dinner. There was always fruit pie, the slices apportioned so there'd be no arguments. I was allowed to watch my grandmother bake, because I didn't get in the way. I dipped slices of cooking apple in white sugar and even then the tartness made me blink. She held the dish up in the air, trimming the pastry with her worn-down knife, and her apron was faded and her arms were soft and floury.

When she called one of the uncles, she would have to list all their names until she got to the right one. Sometimes she got cross: *ach-y-fi*. Take no notice, my mother said with her eyes. We didn't live nearby, but often came to stay. We were put to bed in the back of the car and the headlamps greened the interlocking fingers of the trees above as we drove from the city through the countryside and then, stumbling in through the back door, straight upstairs miss. In the morning I was

allowed to take my grandfather his tea. He always sat in a recess by the hearth. His breath was smoky and the uncles called him the old man and didn't talk to him and he never phoned us, although they often did. My mother would speak quietly, cupping the receiver with her hand; she didn't want to take sides.

SHEETS

We were shaking the sheets so that they billowed like parachutes, white against the sky. I, hopeless, kept letting the ends go. Put some body into it, she said. The washing line hung between the pear tree with the hole in its trunk and a leaning wooden post that was still there when we left the house for the last time, as were the faded plastic pegs that would suddenly snap and catapult themselves into the flower bed where London Pride grew, throwing up its fleshy leaves and pink trumpets. Occasionally, the pegs would land on the other side of the ivy-covered fence, where foxes nested and gloomy foliage filled the once-pristine lawns. Our local nature reserve, said my father.

She did the towels on her own, cracking them so hard the cotton pile stood proud and then folding them, capturing the warmth of the late sun and the grassy air, so that when I took them up to the airing cupboard I kept stopping so I could hold close their sweet roughness. You took your time, she said. The sheets went into the ironing basket, waiting their turn. My mother was quick and efficient, the iron going in every direction and hissing with steam. She had been taught laundry work at school, learning how to starch collars and warm the cast irons on the stove, and how to use a goffering iron for frills and flounces. It seemed like another age.

Three · BRINK

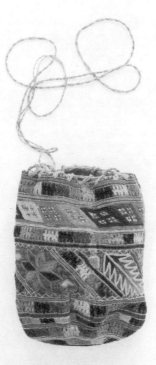

RIBBON

I was looking for a Saturday job. I walked down Chiswick High Road and tried WH Smith's because I liked reading, but they didn't have a vacancy, or at least not for me. I was disappointed, had imagined browsing through its shelves, or sitting behind the counter with a book on my lap, perhaps *Middlemarch*, or *Summerhill: A Radical Approach to Child Rearing* – my mother was studying educational psychology and I was ploughing through her coursebooks faster than she was. Perhaps they realised I would become distracted; perhaps a love of books wasn't a skill set they required.

My father found me a job at Goodbans, the local department store. He would have talked me up; he was proud of my cleverness but puzzled by my diffidence. I was egotistically shy. I was put in haberdashery, its reels of cotton, rickrack and bias binding, pinking shears and tailor's chalk familiar to me, for my mother had the same things at home. But I was outdone by the ribbon: it was slippery and wouldn't lie flat when I tried to measure it, suddenly uncertain of my feet and inches and intimidated by the finality of a wrong scissor cut. Are you new? someone asked.

I went to the staff canteen and drank tea from a green cup and saucer. No one spoke to me. That afternoon I unfolded a pakamac and couldn't get it back into its pouch. We don't take the macs out for customers, I was told. The day seemed very

long. My father phoned up on Monday and said I wasn't going back. I'd come home washed out by my own ineptitude, and anyway I was supposed to be studying for my exams and supposed to be going to university. I was waited on hand and foot, piles of clean laundry outside my door and bus-chasing lifts to school.

That summer I powdered my face in order to look interesting and hung about in Goodbans' record department, reading the back of album covers, not really knowing what I was looking for. When I found John Mayall, the long-haired boy who served me said it's unusual for a girl to like that kind of music. I puffed up with pride and played it to my father, but it made him uneasy. He preferred Procol Harum, loved *A Whiter Shade of Pale* and kept repeating the line about her ghostly face until I got annoyed. He likened it to Shakespeare.

BIAS

I picked up the wedding dress from somewhere. It was from the 1930s and cut on the cross so skilfully that it clung to my body like water. My parents looked at me doubtfully.

At the party I stood in a corner, leaning against the wall, and someone came up and said I was not like the others. I didn't know it was a chat-up line and went upstairs to read, bored of the crush and the noise and thinking perhaps I was different; special, even.

He found me there and admired my silken, slippery skirts and later my friend said he was married. I walked home barefoot and the pavement was still warm from the heat of the day and the wedding dress trailed behind me, gathering up the London dust.

YELLOW PAGES

I was surprised they let a schoolgirl in, that the books I wanted to see would be brought to me, and that I was referred to as a reader. I didn't know such a title existed but was accepted by the librarian as if she had quiet faith in my studies. Each desk was numbered and had its own shaded reading light and the wood was smooth with time, and from the window I could see the quadrangle, its long-gone flowering cherry trees. Above, a narrow wrought-iron gallery ran alongside the shelves of leather-bound volumes that stretched two storeys high. I had no idea that there were a million more books hidden in

the stacks, and it was another decade before I was allowed to traverse that privilege, by going behind the door marked Staff Only.

The invigilator sat at his desk, watching over us. Our eyes met, and I blushed, feeling like an imposter and wondering if I was handling the books correctly; I'd never seen a book support before. I was wearing a Laura Ashley blouse, inset with cotton lace – it was early summer – and the deadline for my dissertation, the first I'd ever written, was looming. I'd asked to see books on Graham Sutherland and Braque and Josef Albers, because of their use of yellow. I wanted to argue that it was the colour of faith, without really knowing if this was true or not. I had alighted on art history and found a teacher who believed in girls thinking for themselves. Go to the National Art Library at the V&A, she said. I felt like a parched traveller who had found an oasis, found their sensibility.

But the night before submission I was struggling. Too proud to ask for help before, I went to my mother and we sat in her study and she typed up my handwritten pages. I needed a conclusion (I've often lacked these finalities) and she helped me find one. I didn't confide in her often; we were both shy with emotion; later, I'd be equally cagey about my successes. Perhaps it was because I was pained by the thought that she, the most capable of us all, never had the opportunities that she made for me. *The museum will be like a book with its pages always open,* said its first director Henry Cole in 1857. Grave and restrained, she was always our invigilator and, had chance been fair, would have been a reader too.

THE SILK ROAD

On the day of the funeral we went to a florist to buy some flowers. It was a wedding, we said. We dressed in bright colours, trying to push away the fear. Life was not solid any more; I felt it dissolve like the raw jelly cubes I ate to strengthen my nails, synthetic colour swirling through my mouth like blood.

Three days later I was sitting my exams. In the sports hall, with the clock ticking time, I took my English A level, without conviction, my friend's absence weighing on me. Perhaps I was awarded some consideration, for I didn't fail, and then, to my surprise, did well enough in history of art. I said to my English teacher, it should have been the other way round. It should have been both, she said.

We set off for India, on the hippy trail, following an invisible path known only to young people, and had no fear that we would lose our way. It started, as it always did, by me walking down our road and getting a bus into town. I tried not to look at the dent in the park railings where my friend had died. We took clothes, traveller's cheques and a copy of *War and Peace*. After I read each page, I tore it out to lighten our load. The book got thinner, and the paper trail we left behind in buses, trains and shabby hotel rooms grew longer. As an undisputed necessity we took a guitar that neither of us could play; I studded its case with Tampax, but every time we opened it they rolled out, became more and more grubby.

We got a bus in Istanbul, and the three days it should have taken to get from there to Herat stretched into many more. The bus broke down and I went to the Turkish baths, and was surrounded and stripped and scrubbed by a group of laughing women until my skin was red. I swopped my tight jeans for flowered tunics and harem pants and wrapped a scarf around my head for modesty, and for the dust.

In the desert the driver stopped to pray. Barefoot children ran towards us, their clothes tinged by the reddening evening sun. They wore embroidered caps, and their teeth were white against their skin. I held out my silver ring, and it was gone before I knew it. In the distance I could see low, black tents. In the morning I was hot, and my chest hurt from coughing.

In Bamiyan, on the old Silk Road between India and China, we showered under a bucket punched with holes, while a boy ran up and down a ladder with kettles of warm water. There was no toilet; we squatted, like everyone else, in the field. The plateau stretched before us, its soaring backdrop two vast Buddhas carved into the hillside. Dogs howled in the night, and the side of the cliff was pitted dark with monks' caves. We climbed up the crumbling stairs cut into the sandstone, saw the curved celestial painting above the Buddhas' heads, and thought nothing of the danger.

We saw a mountain bandit on horseback, bandoliers criss-crossed over his chest, and gun shops lined the streets. I made a banner for the Green Hotel lodging rooms, and we didn't have to pay. Parking. Free camping. Good shower. Cheap room. Cheap food, I wrote in large letters.

We went higher, up to the lakes of Band-e Amir. For the first time I felt afraid, as the bus careered close to the edge of the winding road, and I saw the drop below. The lakes were sapphire against the arid brown mountains, and freezingly, glacially

cold. The beaches were not sand, but vast white mineral deposits that stuck between our toes. We slept on the floor of a bakery, plagued by flies.

We bought a fragrant lump of hash, so fresh it could be moulded in the fingertips. The smiling boy that we liked ran over the hill towards us, followed by a policeman, khaki pants billowing, and felt cap askew. My friend was interned, ankle chains around his ankles, while I borrowed dollars from some Americans and bartered for his freedom. We were told it was a ritual; bribery would out. What's to stop them from shooting us, I thought, although we had nothing to steal.

We cashed our last cheque and turned for home. Our visas were running out and I had to go to university, or I would lose my place. In the covered market we ran our hands through bowls full of turquoise. It was flecked with gold and sold by weight and each gemstone was like a miniature world. I saw a tiny drawstring purse and thought by its fineness that it was old and have it now, beside me. Knowing we might never go back, I bought a dress. I longed for it because its heavy, embroidered yoke and mirrored scales seemed like a breastplate for our time.

Pilgrims of a day
in the vernal Equinox
among the Buddhist Temples.

Four · VERDANT

FORSYTHIA

No, winter flowering jasmine, she said, as I mistook the arcs of citrus yellow flowers that sat in a vase on her desk for forsythia. I got the feeling forsythia was downmarket. I liked it, though, because it grew in the front garden of my childhood home and blossomed when everything else was bare, the flowers emerging all along the lattice of branches that covered the fence.

I filled a glass with its awkward stems in the early spring. I'd arrived at university the previous September, coming on the train from London to a West Country city where I could see fields from the high street. My room had a stained-glass door and was on the half-landing, overlooking someone else's garden. I sat on my bed and wrote letters, and the forsythia reminded me of home.

Last year I planted forsythia near to a ceanothus I took from my father's garden, its blue flowers the colour of his eyes. The hose didn't stretch to the end of the garden and the grass was parched and mossy here. Piles of wood lay rotting, breeding spiders and woodlice, and foxes burrowed under the fence leaving a litter of licked-clean cartons and stolen toys. But I liked its scruffiness because the trees once marked the boundaries of fields and because it was too far away to hear the doorbell. On rainy days I could sit in the greenhouse and watch the drops bounce off the glass. Here was where I had my forsythia. I didn't mind that it wasn't perfumed, for I'd lost my sense of smell.

HAIR

My mother combed my hair carefully, twisting the curls in her fingers, untangling the tangles, and wondered if she could buy me a hairbrush. She was concerned I wasn't making enough of myself. I said, stop, for her touch made me drowsy.

I made a point of not brushing my hair, allowing it to spring in all directions. Its wildness suggested I was carefree, although in truth I was not. At a Bob Marley concert, someone I'd been eyeing up came close, murmuring, you've got fantastic hair.

The tarmac melted in the lanes and the hedges grew tall and wild, enclosing us in a green tunnel of heat. Clouds of midges gathered as we collected sloes to make jam and tendrils of hair clung damp to my neck. We were following a Richard Mabey recipe, and it seemed to take all summer.

I lived with a smiling, red-haired girl. She often didn't come home. I answered the door to one of her friends, my hair wet and slicked back. You look like a boy, he said, as the shutter clicked, for he was studying photography. I kept the grainy print for years although barely knew myself.

In my top drawer there is a hairbrush with a white hair entwined around its bristles. For years she had coloured it, leaning over the sink with black smudges on her forehead and the smell of damp chemicals. Your mother's hair looks so much better now she's stopped dyeing it, said my aunt.

I'm sitting at my desk, wearing faded red espadrilles, an

untidy plait hanging down my back. I was restless and said it with my hair. I left the museum when there was no more to lose, for I was moving on, away from the rules and the paper-work, and from someone who loved my hair.

I think of all the strands that have clogged sinks and plugholes, and that fell out in handfuls after the children were born, that I've left behind on pillows, that tangled in my mouth on windy days, that she rinsed with vinegar for the shine and that she once said was my crowning glory.

SEEING

I took my contact lenses out and put them on the dusty carpet next to the bed, then licked them clean in the morning before putting them back in. We had a party, and someone knocked the back of my head. He was theatrical and used his arms a lot when he was dancing and liked me because he said I smelt of tangerines. When we swept up the next morning, the lens was there, broken in half.

I lost my contact lenses all the time – once in the lanes on the way home from the pub. There was no traffic, just the sound of a cow coughing in the field. We stumbled around in the cold Devon air and the black sky was pierced with stars and our breath was coming in short gasps. The lens glinted in the feeble light of the torch. Amazing, I said, picking it up. We said *amazing* a lot.

We were about to leave for a Midlands wedding. No one we knew had ever got married. I had an old Austin 1100 and hoped the missing pages on the road map weren't the ones we needed. I ran the tap in the sink and my lens fell out. I tried to put the plug in, but it had been washed away. That hadn't happened before. Oh no, I said. Perhaps it was for the best; I was not a seasoned driver.

We went down to the village post office and queued up to send a telegram. I had difficulty deciding what to say and had to pay per word, so kept it short:

Lost contact can't come love Claire

Apparently, it was read out along with all the other wedding telegrams, as people used to do, and her aunts and uncles couldn't make head nor tail of it.

* * * *

I had started getting things wrong when I was younger, even though I sat close to the blackboard. I went to have my eyes examined and didn't have to go to school that morning. I kept changing my mind because I thought it was a test and wanted to do well. The man got cross, and I got flustered and my mother said, just say what you can see, Claire.

My father photographed me standing on our front door-step in my new glasses; National Health, with their own case and cleaning cloth. I started secondary school and my hair went frizzy and my nose seemed to get bigger. A builder shouted out, it's John Lennon. I was carrying my violin and he added, have you got a machine gun in there? I gave up playing after that.

It was the summer holidays, and I was going to see the Rolling Stones. I left my glasses behind on the Underground and could hardly see a thing. Brian Jones had drowned two days earlier. Mick Jagger wore a white smock and white trousers, and thousands of white butterflies were released. They looked blurry to me, like confetti.

He hath awaken'd from the dream of life, Jagger read from Shelley's *Adonais*, stumbling slightly over the words. I especially liked the line *Life, like a dome of many-colour'd glass*; it reminded me of a Venetian glass paperweight. Shelley drowned too, in Italy, a year after Keats died, who he had written the poem for. I look at Shelley's portrait. He is wearing a white shirt with an upstanding collar. It seems to be the garment for poets.

Jagger's white smock was by Mr Fish, who had a shop on the King's Road. It was really a hybrid, a cross between a shirt and a dress with ties down the front and billowing sleeves. I liked the way Jagger swished the peplum as he shivered his body, while the cabbage whites fluttered and settled on people's clothes. Most of the butterflies died, their papery wings torn and trampled by the crowd.

At some point, after a decade of near disasters, I gave up contact lenses; my friend noticed that I'd walk along with my head tilted back – as if looking for stars – and this was probably because I was worried I'd blink and they'd be gone. He liked me in glasses. I didn't lose them any more because I really needed them. It would have been strange to go about the world unseeing.

KIMONO

They lived over the road. Their house was large and shadowy and filled with books and papers and all sorts of old things, and they seemed complicated and well informed. I found a silk kimono in their dressing-up box that I wore all day, even though it dragged around my ankles. In the end they gave it to me. I think my silent insistence won them over. Years later, I found another. It was a watery green with a sketchy pattern of trees in blossom on the back. The pink of the blossom had faded. I liked wearing it because I knew it suited me and because it was soft; *compliant*. I wore it to shreds.

Today, I have a cotton kimono, printed with swirls of pale blue and buff, and it is the ideal dressing gown. Kimono are cut square, so that they lie flat. This has many benefits, because they can be folded up easily, unlike Western clothes that are tailored to fit around the body. The kimono stands proud, so that all the focus can be on the fabric and the pattern, and looks good from both front and back, whether trailing or gathered. In *The Tale of Genji*, which took me a full year to read, so that by the end I had forgotten what the beginning was about, I learnt that the sound of the fabric was important too, that the rustles and whisperings of the layers were seductive to the senses, caused arousal.

The kimono I found in the dressing-up box had aroused my senses. Its weightlessness, and the way it enveloped my body

without demanding to be fitted, or borne like my heavy school coat, made it feel the most yielding of garments. I yearned to have interesting things, to be well travelled, to live in a shadowy house full of books and papers and all sorts of old things. I too would be complicated and well informed.

TAPESTRY

When I first arrived at the bedsit my hair and skin still smelt of the road. I replaced my threadbare kurtas with flowered crêpe dresses and itchy mohair cardigans, reddened my hair with henna, wore wellingtons and carried a wicker basket, its contents and my life open to the world. In Cullompton, I came across a jumble sale in the village hall. It was deserted, and I bought all I could carry – silk blouses, dainty underwear, lace tablecloths, prize-given books with ornate covers, old photographs, china; a treasure chest of another's life.

I thought I was worldly, but the truth was, no one cared. I wore a brass ring that turned my finger green. A nomad somewhere between Kabul and Kandahar had given it to me. I drank tea and ate apples and smoked roll-ups and kept the Golden Virginia in a round halva tin from Turkey that I carried every-where. I still have it, although its gold and blue paint is chipped and its edges a little rusty.

I moved from damp cottage to damp cottage. My tutor said if I was in trouble, I could stay with him. I turned up that night in a storm, with two mewling cats in a basket. He taught me to play darts (shouting Arrow! when I hit the target), made me listen to Mahler's Ninth, at full volume, read poetry out loud, said *the drive is curiosity and the aim enlightenment*. And I,

not knowing what else to do, cooked him quiche and lentils, recipes from Elizabeth David's *French Provincial Cooking*, a parting gift from my mother. His girlfriend was another student, and their room was in the attic, the floorboards bent with the weight of his books. He wore flares, and thick jumpers that smelt of Old Holborn, and had a Zapata moustache and intense eyes. He was barely older than us and when I looked him up some years ago I found he had died. If only I had known the centrepiece of his career had been the Victorian Society and the Albert Memorial; our dust-mote library, his too.

A tide swept me back to London with its gloomy pubs and sooty parks. I burnt my papers, sold my books (but kept *Keats and Embarrassment*, for the title), gave my clothes away and abandoned the cats. They had hunted rabbits and crows and left the bloodied bodies as gifts and I couldn't cope any more. I missed the gentle boys who stayed on, with their records, and their long hair, and their jumpers full of holes. I missed the soft green verges and the wildflowers of Devon's lanes, the summers lying on scorched grass, and the damp winters reading novels in bed and coaxing a smoking fire for warmth. I missed the person I might have been, but I couldn't go back.

PURPLE VELVET

I felt that nothing but her velvet trousers would do that day and plucked up the courage to ask. They were too big, and I had to fasten them with a safety pin and the hems dragged, but still I thought they were a triumph. My friend's charisma and confidence were evident in everything she did, from her handwriting to her sardonic comments, but especially in the way she dressed. I had a crush on her and wanted to wear her clothes.

Her face was delicately drawn, with a pointed chin, high cheekbones and flushed cheeks, and her eyes were dark and lively with eyelashes that looked painted on; a Reynolds kind of face. Her hair fell to the side like a boy's and she swept it away with her hand, especially when she laughed. She specialised in self-deprecation, but that only offered me the opportunity to flatter; reassure.

When she entered a room, life suddenly seemed meaningful. Her opinions were, I thought, perspicacious and her gossip amusing, and she had an exquisite touch when pouring tea or pushing wildflowers into a jam jar. When she gave me a lift, I loved the way she committed, taking corners with bravado and putting the handbrake on with a flourish when we arrived, as if that had been exactly what she meant to do with her morning.

Once, after we'd all moved to London, I took a carrier bag of trappings and trimmings, velveteen and violets, to her flat. I wanted to give something back, to say: I have studied your ways

well, and think I know how to clothe myself now. But it was a mistake because she was having a party and I hadn't been invited. For years after I would wonder what she was doing and if she ever thought of me, never knowing what I'd done wrong.

Five · STOREROOM

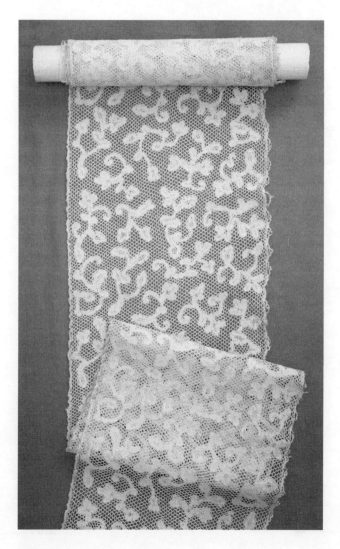

MAIL ORDER

I was working in a basement just off the Fulham Road. I had to pack the orders in brown wrapping paper and take them to the post office. The stock was kept on metal shelving and I had no idea what people did with most of the things.

It was the summer of 1977, and one of my jobs was to pack gift sets of Jubilee Knickers; sheer and crotchless and trimmed with a satin bow. I quite enjoyed varying the order of the colours – red, white and blue – and snapping the boxes shut with elastic cord.

I didn't really have enough to do, and the days seemed long. I listened to the radio, drank instant coffee and spent ages on the phone, hanging up quickly when the owner arrived. At lunchtime I ate my sandwiches slowly before reluctantly putting my book aside.

Sometimes letters would arrive with an order. See-through baby-dolls with matching suspenders were popular, as were the corsets with their trimmings of harsh black lace. The patent stiletto boots came in very large sizes, I noticed, cramming them into their boxes.

My friends were amused. I stole some arousal cream for them, just for a laugh. It burnt like hell, they said. They had us round for dinner but there was a miscalculation with the dried chilli peppers. I stuck my head in the sink, cold water dripping everywhere.

THREAD-COUNTER

My employer seemed the most unexpected devotee of lace, confounding my expectations. He was not a curator, but still he liked to get things right: count the threads; consult the experts. He would stand there with a frown, trying to understand it all.

I'd started working for him after I got the sack from the sex shop – doing the laundry and mending linens. I was dazzled by the transformation and rehabilitation of the dirty, yellowed whites bought in bulk at early-morning markets. He called it his swag.

I saw how he appreciated age and history and hand-stitching, although the exquisite rolls of lace that he lovingly graded, ticketed and sold on could never attain the value they'd once had, nor recover their extravagance as an accessory to high fashion.

When I went to the museum, I knew I'd come from trade but it stood me well, for everything that has ever had value has been transacted, and in its heyday lace was an economic miracle, weight for weight, thread for thread; more valuable than gold.

In the museum, the lace felt weightless in my hands as I rolled it onto tissue-covered tubes, securing them with cotton tape. We stored them in clear cellophane bags with the numbers written on bits of paper. That way, you could find what you were looking for.

THE SKIRT

I was having trouble with the tension and the thread kept snapping. I licked the end and leant forward to thread it through the needle of the sewing machine. I was making a skirt, at speed; two side seams, then the material gathered onto a waistband, an uneven tube of fabric that I'd made too narrow so that it was fiddly to turn inside out. It was looking crumpled, so I ironed and pulled it straight. I was going to secure it with a safety pin because I had no idea how to make a buttonhole, and little inclination. I should have hemmed the skirt by hand, for it rucked up slightly because of the tension problem, and this I did regret, but it was late and I wanted to wear it in the morning, and I was keeping the people downstairs awake because the rumble of the machine was just above their heads and they'd already come up once to complain.

The fabric was an ikat in delicate shades of grey and pink, the pattern diffused, because the warp had been dyed before the weft was woven through. This much I had learnt about weaving techniques from my short time working at the museum, although now I suspect that it was printed. Either way, I thought it would look good with a white T-shirt, and that's what I wore the next morning, for it was the summer of my first proper job. I set off on my bike down the Fulham Road, hair flying behind me, running late as always. I was on key duty, and it

was my turn to unlock the pull-out frames which were stored in mahogany cabinets in the Textile Study Rooms.

The frames were numbered in gold and stacked vertically and could be pulled out of their recesses using a brass handle. They contained textiles of every date and type, flattened behind glass, from fragments of Coptic tunics to eighteenth-century bizarre silks and nineteenth-century printed cottons, all stitched or pinned onto backboards, and little changed for decades judging by the faded typewritten labels. Enthusiasts studied them with magnifying glasses at a special table. At the end of the day we had to check all the frames were back in the right place and lock them up again. Sometimes, on the way home, I would worry that we'd missed a case and it would trouble me, even though we never did.

My desk was in the general office and there was a Turkey carpet on the floor that might have been from the collection. It had a hole in it that kept tripping me up until I got the hang of stepping over it. I sat opposite a young man who wrote poems and I smiled at him over my pile of books and someone said he was lovesick. When the senior curators came into the office, I kept my eyes down, in case they asked me to do something tricky. They liked him because he always jumped up to help – they thought he was Keeper material. They didn't say that about me.

I liked being in the storerooms best and would take my time putting things away. I didn't mind the weekly Opinions afternoons either. They were very popular; people sat on chairs all the way down the corridor with parcels on their laps, and sometimes suitcases, which meant either they'd brought something large, or had brought a large number of small things. Conversations took place there and then, with the curators leaning over to have a look and everyone else listening.

Sometimes if it was a complicated object or needed further investigation – a potential donation, perchance – other curators were called in. Sometimes, a rare piece materialised. We would gather round, listening closely: a sampler, worked by a child; a length of Brussels or Valenciennes lace; a particular cut of gown that could be dated not just to the year, but the season, for fashion it ever was. Once, a box of medieval leather shoes arrived. We were all sent home, and a specialist wearing a white boiler suit and mask had to be called in to isolate the shoes, in case they came from a plague pit. I brought something in myself once, before I got the job. Curiosity had led me to open what looked like a dull brown leather pouch at a market stall, only to find it was a folding wallet, lined with yellow silk on which was embroidered in gold thread: 'Sr William Portman Constantinople 1682'. Wallets like this were used for letters, bank bills and valuable documents and were sometimes brought back as souvenirs by travellers or bestowed on visitors by foreign envoys. I gave it to the museum, for I had no use of it, and there it rests still, along with my purple Biba boots.

LADDER

The textile store was so long that it was hard to hear what people were saying at the other end, and if the phone rang we had to run to answer it. The store had not always been a store. Many years ago, one of the museum's original galleries had been requisitioned, and it had been furnished with second-hand specimen cupboards from the Natural History Museum. The gallery's arching metal struts had once offered views to the galleries below but now were boarded over and blotted with thick cream paint to keep the light out. In the textile store, the outside sounds of the museum were muffled, although sometimes we could hear the laughter of school parties as they passed by with their clipboards.

The two of us were doing the audit, the quinquennial, for it took that long. Every August, the department closed for a fortnight while we went through the cupboards and drawers to check that each object was in its designated place. If it was, we placed a tick on our checklist. Now and again something was not where it should be, but we would usually find it in the drawer above or the drawer below, perhaps misplaced by a curator fatigued by the stale air and the demands of visitors: cloth workers; historians of weave; practitioners of stitch. Sometimes, pieces were nowhere to be seen. Regretfully, we marked them as Not in Place and carried on.

We worked in pairs so as not to make mistakes, like nurses doing a late-night drug round. We took it in turns to be the person with the pencil and checklist, and the person reading out the number attached to each piece, given to it when it was acquired by the museum. For example, T.45–1975 meant 'T' for textile and '45' for the 45th object acquired in 1975. Older acquisitions had tiny labels made of parchment, with the number and date written as if with a quill. Some predated the museum's organisation into departments and so did not have a prefix, merely a number. Some did not think to include the full date, for example marking '59, rather than 1859, or '99 rather than 1899, as if the nineteenth century would never end.

In recent years we had written the numbers and dates on woven tape using a laundry pen. The ends were tucked under and stitched onto the fabric, like a school nametape. In the case of hard objects, like shoes, someone with a steady hand painted the letters and numbers on the underside, using a fine brush. Sewing labels on was one of the jobs we had to do when we weren't doing audits and it was something I enjoyed, making my stitches as small as possible; thinking it my legacy. Sometimes, we spent the afternoons answering enquiries. Now and again we'd receive a letter addressed to the *Victorian Albert Museum*; it always amused us.

One of us would read out the numbers, like a bingo caller. Number, tick; number, tick. We had to be careful. We had been told of a rare piece of lace that had been thrown away, caught up in some folds of white tissue. LOST was written in capitals on its record card, meaning the piece had gone forever. As we went through a very full drawer, we found that a lappet was missing. We shook the tissue, searching, but found that we had been tricked; it had been stitched to its pair, for lappets –

long streamers of lace worn either side of the face that were fashionable in the eighteenth century – come in twos, and we had missed one of the numbers.

With the lower drawers, we could lean in and sort through the folded pieces quite easily. If they were very full, or there were lots of tiny bits of fabric that needed careful repacking, we would lift the heavy drawer out onto the table, carefully transferring its contents onto tissue, before putting them all back again. But with the higher cupboards this was more difficult. We had to climb the ladder. We were always given the higher cupboards to check because we were the most junior members of the department, and the most agile.

The ladders were parked either side of the storeroom with a flat platform at the top that held one person comfortably, two at a push. One of us would stand on the platform, the other would balance below on the steps, looking up at the underside of the drawer. We couldn't remove the drawer because it was too heavy, and we were working at height now. At the top of the steps the atmosphere was warm and musty because the air conditioning was outdated. Our heads were within touching distance of the girders, just as I imagined the heads of the museum's builders with their cloth caps and handfuls of rivets would have been, as they bolted and hammered the metal struts together.

* * * *

The smell of naphthalene pervaded the air as we checked through a cluster of medieval caps. Lots of these had been found in London, as ever-taller buildings required ever-deeper excavations. The felted wool was designed to be warm and waterproof and, although the caps were hundreds of years

old, looked as if it still might be. In the next drawer along there was a group of top hats dating from 1820–1930. Each was sealed in a clear plastic bag marked with a skull and crossbones because mercury was used during their making and they were still toxic – caused madness. We detected the museum numbers through the safety of the hats' protective membrane.

We were on our own in the quiet of the textile store, at the top of the ladder, absorbed in our work. There was going to be a thunderstorm, and the air was electric and the hairs on my arm stood on end when we accidentally touched. Later, back in the office, we drank our tea; it was tiring, doing the audit. We handed our results in, our losses and findings, for today had been our last day. But I longed to be back on the ladder, our arms touching, and smelling the smell of naphthalene.

Six · CATCH

THE CAT

I once had a roof garden. The compost that I hauled up the stairs became dry and crusted and plants wilted in their terracotta pots. Water evaporated instantly, absorbed by the snatching wind and the ruthless sun of the hot city summer. I bought deckchairs, and we sat imagining we were living life to the full, with our beers and our music and my white shirts ridged with dirt from the washing line.

Here, I walked into a television aerial, blinded by the brightness, and staggered backwards as a weal rose on my forehead, slowly oozing blood. I climbed down the shaky wooden ladder and sat on my bed, a flannel pressed to my brow thinking that could have been my eye, and thinking too of the shallow parapet that I could have tumbled over, and the five-storey drop to the road below.

My cat ran onto the roof, and appeared on next door's window ledge, crouched low and crying into the traffic. The firemen returned her ungrateful, ruffled self; it was a quiet night for fires. The next day it happened again. This time I waited, and then, in the early hours, heard the cat flap swing, and slept finally, feeling a shuddering warmth against my feet, atonement for the scratches freely and abundantly given.

The cat was neurotic, everyone agreed; it had been taken away from its mother when it was too young. I was ambushed every night-time pee, my ankles criss-crossed with scabs. Boyfriends

were amused until they too were sent shouting and hopping back to bed. One young man was rich and pampered; he folded his shirt, and his underpants were snowy white. I think he thought I was an adventure.

Then you appeared, dark and glowering, and she decided to make her peace with the world, and lay purring around your neck, globules of saliva on her chin, looking at me through green-chink eyes, clawing intermittently at your black jumper. I sketched you as you lay absorbed by some television programme, endeavoured to capture your screen-lit face. The cat looked like a black scarf, no matter what I tried to do.

I painted your portrait again, when it was too late to be an artist, filling the page with scrawls and rubbings-out and blurrings of your face, now older, shoulders more sloping than they had been, but still that firm brow and those pulling curls that adorned your head like a febrile crown. And around your neck, the ghostly feline shape of that tamed fury, and me no longer angry either, but sedated and sated by your consistency and love.

KEEPER

The Keeper's hair was twisted into a bun and she wore glasses and flat shoes. When she walked through the galleries she stepped quickly, swinging a bunch of keys. Sometimes lost visitors intercepted her, asking where the tapestries or the patchwork quilts were, or for the way out. She was helpful, earnestly agreeing that the museum was a maze.

The Keeper taught us how to be public servants. We copied her mannerisms, were prompt, reliable, respectful. Our in-trays held erudite journals and we welcomed complicated enquiries. We expressed tentative interest in obscure aspects of the collection. Once, early on, I said I liked the eighteenth century. It's a good century, she said kindly.

The Keeper believed in tacit experience and we learnt without realising it. She asked me to unpick a lace collar that had been stitched onto a faded backboard. I used a scalpel to slice through the threads, and when the lace was released, a shadow collar had been imprinted onto the blue velvet like a daguerreotype. This was a lesson in light damage.

That Christmas, we had a staff lunch. I was surprised when she ordered chips, had somehow thought that Keepers did not need such comestibles, that the ether of objects was sustenance enough. I imagined being like her one day, swinging the keys of knowledge. But back then, I was just a shadow curator.

SILVER THREAD

I knew how far I had to go and how hard I had to work to become an expert. But I was out of my depth, and my French – the language of textile history – shaky. Perhaps I had been to the wrong university. Perhaps they thought I was lightweight because my love for the museum was conditional. I liked painting and drawing too, and dancing, and cycling through Hyde Park on summer evenings with my short skirts flapping. The vast knowledge of the experts reduced me to silence, and I didn't know how they knew what they knew.

I'd had enough. I phoned Camberwell Art School on a dreary Friday afternoon, and discovered that they still had places. I took my portfolio and at the interview the smell of oil paint and the purposeful bustle and the girls in dungarees with their Doc Martens and their hair tied up with bright scarves made me feel alive, as if I'd had a lucky escape. I announced at the museum that I was using my annual leave and leaving. The Keeper expressed regret.

On Foundation, I learnt to paint chalky frescoes, sculpt clay, charcoal sheets of newsprint with approximations of life models and wield oils with a palette knife. The freedom of dirt and mess, and the splashing of colour and intense conversations crouched on the floor were like a reversion to childhood. I was a decade older than most of the students and surprised at their confidence, touched by their respect for me. I wanted

to do fine art, but lost my nerve, not sure I had anything to say.

I was, in the end, pulled back by a silver thread, by a sea change at the museum, a lightening of the galleries, a cleaning of the cases, an efflorescence of excitement about the possibility of fashioning the gap between the sweat of the studio and the serenity of the storeroom. I imagined a blurring of the senses, artistry in movement, redefining what a museum could be, patching order to the chaos of making; for everything that had ever been carved, gilded, chipped, woven or embroidered had felt the sweat of the hand and the mess and noise of the workshop; the irrational investment of the artist and the expert. Although I had come full circle, I never regretted my art-school years, for I look at the collections now with the eye of a nearly-artist.

Seven · UNBOUND

LIFE MODEL

I was reclining in front of a room full of people working away at their easels. The silence was only broken by the tick of the electric fire, the scratching and rubbing out of charcoal and pencil and the odd sigh; I felt a sense of tranquillity and anonymity that was enhanced rather than disturbed by my nakedness. The tutor murmured the odd comment, and then said, we'll take a break now. I slid off the plinth with its dusty canvas drapes and put my dressing gown on behind the screen, feeling more self-conscious than when I had been undressed. Some of the drawings were cautious, dark with reworkings; others sketchy, approximate, dotted and dashed. I complimented someone on their work; liked the way they had rendered the folds of the drapery, observed the curve of my spine in repose, noted the fineness of my ankles, marked the swell of my stomach, implied the weight of my breasts. They seemed pleased but didn't meet my eye. We'll take another pose now, said the tutor.

THE COT QUILT

I set off every Friday night in a Ford Pinto the colour of pea soup, hemmed in and hustled on every side. The interstate gradually began to empty as commuters took their leave and, apart from the odd truck heaving and blaring past me, I found myself the only car on the road, its weak headlights throwing their beams into the darkness. I was worried about breaking down or running out of petrol (it was before the age of the mobile phone) and my hands were sticky on the steering wheel: don't miss the turning, I kept saying to myself.

I drove the last few miles past Civil War battle sites and closed malls, before drawing to a stop. I turned the engine off, listening to it pulse and cool in the night air, and I, too, readjusted from speed to stasis. When I stepped out I could see constellations of stars and felt dizzy with inconsequentiality. The only light was coming from a window in the house and the air was crisp and pure, for the valley, with its farms and smallholdings, was enclosed by tree-cloaked mountains where, it was said, black bear roamed.

The cold was profound that winter. I pegged a shirt out to dry (no one but us dried washing outside) and within minutes it was frozen stiff, and I had to prise it free and carry it into the house with its arms outstretched like a scarecrow. Inside, our

only source of heat was a stove that burnt so furiously that the flue glowed red and shook with the force of the flames. Perhaps we should have been more careful. The house with its rickety veranda was built entirely of clapboard, weather-beaten, peeling and dry as tinder.

My friend made pots in the dim basement out of local grey clay, listening to the World Service, barely speaking to a soul. There were no neighbours, just scrubby fields full of sheep that left greasy wisps on the fence to flutter in the wind. We knew another potter who lived in the woods and had dug a kiln in the side of the hill, and the firings took days and the nights were vigils, as we fed the fire with wood and saw its roaring innards, and the pots, translucent in the shimmering heat, beginning their conversion into solidity.

Towards the end, we went to a fair and bought a cot quilt for the baby we had to have. Winter had turned to summer and the heat was building as we waited, for it was the last item in the sale, and we got it for a song and took it home to the wooden house and laid it on our bed with its shiny mahogany posts, and there were wildflowers on the bedside table. The shutters that had once kept the cold out now kept the cool in, as the sun beat on the weatherboards, and we drank lemonade on the veranda, reluctant to leave our new-found-land.

COUNTERPANE

I borrowed a pair of glitter-flecked wellingtons and felt like a child as I struggled up the hill. The wind teased and threw twigs at my hair. The garden sat on a slope, its low walls built to stop the slide. Overgrown marrows lolled on the bare earth and, as I tipped the bright peelings into the compost, I saw that underneath the rot-darkened mass was slowly returning to soil.

The box hedge bounced under the flat of my hand. I imagined lying on its prickly green springs, looking at the deepening sky and waiting for the equinoctial moon to rise over the treeline before the countdown to winter, as the days weakened and relinquished their wasted hours to the dark blooming of the night.

But I moved on, pushing through a greenway dripping with leftover rain that got inside my jacket and trickled down my neck. Birds darted low. I was looking for something, a bench on top of a hill, a view of the Shropshire valley with its counterpane of fields, and low clouds that made me feel it was us slowly moving, not they.

Leaves shivered in the breeze and the sun came out and at once I was upon it. The bench was scored where damp had forced the grain apart but the brass plaque was still bright. Rain patted

my hood, and I was afraid of slipping as I baby-stepped back down to the house, like someone who'd lost her ground.

I once sat on a bench, looking forward to when we would become we. Somehow, the fates were cruel, or medicine was faulty, or nursing lax, or luck was bad, or death was greedy, for not long after I lay on a narrow trolley, looking not up at the spring-flushed moon but at rushing, fluorescent light.

I felt my vision darken, and stumbled up the stairs to sleep and later, when it was night, a kind stranger came home and said did you see the moon. I missed it. I was thinking instead of our lost child and wondering where his memorial was, and how on earth we were to locate our grief.

Eight · ENTWINED

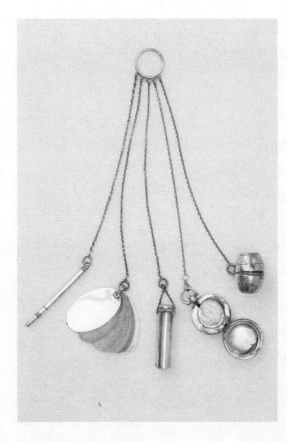

LUSTRE

The museum has a miscellany of period rooms lovingly disassembled from their sites of origin and re-formed for us to look into and wonder. They are enclosures of time, panelled and mirrored and gilded, shelved and sometimes bedecked with porcelain. Foxed reflecting glasses hint at the ghosts of ancient families, beset with privilege, adorned in glazed and filigreed silks, turning and smiling and weaving through the throng; the cream of society.

My own interior of wonders is humbler, a pottery I visit, dusty and dry and functional. A brown apron hangs on a peg, its strings limp and trailing. Glaze tests line the walls, like a stiff patchwork. Rulers and measures, tapes and weights attest to this most Cartesian of preoccupations. Science, mathematics, earth and fire amass to colour and fuse the clay's inert, heavy mass; modelled and thrown and carved, it becomes shaped and glazed into forms of outward simplicity, belying the epochs that forged it, its ingredients sourced from underground deposits of silt and earth, veins of ore from far plains and mountains, sand ground by millennia from granite, stream water lubricating the molecules.

Here, in the studio, hands stretch those molecules out, knead the clay, expel the air, smoothing and turning and forming: see the centrifugal force of the wheel, the slip rushing off like spit and the leather-hard trimmings building little mountains

of slag, destined for reclaim bins where the stagnant clay slowly greens. Feel the heat of the kiln, the slow pressure of fire, the expulsion of trapped oxygen molecules, and the subsequent shrinking down and hardening, white hot to dull red, then cooling, cooling, cooling, before the blast of fresh air as the kiln door opens and the dry touch of bisque, the scrubbing with water, then the glazing and the reduction, the glassiness and the judgement, the expulsed and the exceptional, the transition of piece from hand to hand, maker to handler, a voyage away, along the trade routes of ages, weighed-down boats crossing the sea, and now, in reverse, new forms in transit, fragile vessels taking the perilous journey back to their source, back to the porcelain rooms of the museum.

HOURGLASS

Here they are, the sombre-clothed men, the buttoned-up women, and the unsmiling babies in their time-bleached lace. I avoid the thought that all are gone, without exception, and look into the images, hoping to get a sense of history, to imagine the novelty of going to an art photographer's studio and having your likeness taken for the very first time. Some seem to confront the new world of technology with bravado, pose as if they've been doing it all their lives; others, from when it all began, when skirts were vast and faces small, express apprehension.

I like the theatre and artifice and the painted backdrops of the studios, with their swags and classical columns and doubtful perspectives. Seating features inordinately, for it was a useful foil: antique carvers; a velvet chaise longue; button-backed armchairs against which the equally upholstered and adorned could lean, insouciantly. Desks or lecterns or books to suggest studiousness; a letter in the hand to evoke thoughts of those far away; a basket of flowers or nosegay to denote youth.

It became all the rage to collect cabinet cards with images of relations, friends or the immortalised, and keep them in lavish, specially designed albums to show off to visitors. *The loved and loving all are here; Just as they lived they look; Life's sweetest memories they recall, And sacred make the Book.* Most albums have been dispersed, their people scattered through

flea markets and the Internet, where for a few pounds you can buy a glimpse into the past, and the mood of the fashions that defined it, should that appeal; how skirts were worn so long that the fabric crumpled where hem touched floor; the way

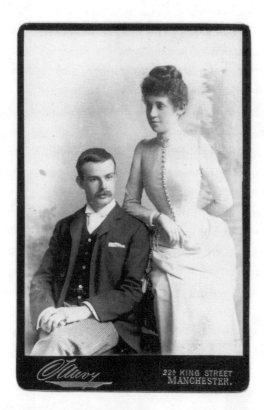

whalebone corsets moulded and immobilised; how sleeves, cut tight under the arm, impeded, received sweat stains; the way the fall of a collar and the turn of a cuff provided punctuation marks for those detained by fashion.

Some of the cards are fancy, with gold-tipped edges and elaborate advertisements on the reverse: *Maison Française for Art Photography* says one. As with clothes shops and milliners,

to be Parisian was the thing. It was where the portrait photograph or *carte de visite* was patented in 1854, and where fashion photography took off, with Charles Frederick Worth adopting the principles and poses of the calling card as his modus operandi for recording and disseminating his fashions, for copyright and for glory. Worth was the father of haute couture, this most French of fashion systems, launched by an exile from London, so uniting the two cities in a battle between the *flou* (floppy material such as silk and organdie, which Paris was good at) and the *tailleur* (tailoring with wool, imparting structure, at which London excelled).

Replication, as with fashion, was the revelation and raison d'être of photography. Half a dozen miniature portraits could be taken on one glass-plate negative. Sitters then chose their favourite likeness, which was printed, cut out and mounted onto thick card. The negatives were stored should more copies or enlargements be needed, to be further circulated and shared. Prints could be hand-tinted to order, even to life-size, and sometimes these ghostly portraits can be found in second-hand emporiums, framed as if – but not quite – paintings and not quite photographs either, but a faded echo of both.

My favourite cabinet card is by *Monsieur Sauvy of Paris*, who lived from 1852 to 1916 and who was genuinely French. It shows a couple from around 1886–93. The quality is luminous, and it may have been taken under electric light, which Sauvy introduced in 1892 in his studio at 22 King Street, Manchester. Here my man sits in striped flannel trousers, pearl-buttoned waistcoat and jacket. A white tie nestles under his stiff collar; his cuffs are crisp and he wears a signet ring on his little finger. His bottom lip is sensual under his moustache and his short hair carefully combed to one side. Bar the watch chain and pocket handkerchief, he could pass for a man of today.

She, on the other hand, is all period, and stands with arm lightly resting on his shoulder, her torso encased in a close-fitting bodice, upheld by her handspan waist (I could mention here the hourglass, a device to measure time). Fabric complications swathe her hips before being resolved into a bustle at the back, making of her an S-bend. A smoothly coiled hairpiece tops her dark frizzed fringe and such is the quality of the image that I can see a gold brooch – a bird with a seed pearl in its mouth – pinned to her collar. Her left hand is hidden. I don't know if there's a wedding band.

Neither looks at the camera. His glance crosses hers and, although their eyes don't meet, there is congruence, an easy intimacy in their stillness that belies the constriction of her outfit and the symbolism of the chatelaine that dangles from her wrist, with its dainty scissors held captive in their sheath of silver. This accoutrement goes back to the age of courtly love, when the chatelaine kept the castle's keys about her. And when the fashionable went hunting – as they forever do in some tapestries, that I know well – we see purses, keys and all sorts of hardware, including daggers, hanging from embroidered waistbands.

Out of the blue comes a WhatsApp message from a friend who lives halfway across the world; he's found a photograph of us from years ago. Here we sit, side by side, me leaning in. Our dress is monochrome, and my dark hair is piled on my head and my only accoutrement is a gold watch that encircles my wrist and that I have still but that has stopped telling the hours. I have no wedding band, or chatelaine. We too are still, cautious in our pose, as we wait for the shutter to fall. We too can be replicated by the magic of technology or enlarged by stretching the screen, as I do now with my fingertips, the better to see ourselves in time.

BOUND

He set off to Oxford Street, the baby in a corduroy sling held close by a complicated series of straps and D-rings. We'd heard about a menswear sample sale, and he needed a suit to get married in. Dark blue would be nice, I said, thinking of how we would look side by side, me in my crisp white linen and he, tailored to a tee.

He put the baby on the floor while he perused the overflowing rails. I heard about the confusion with the sizes, and the trousers and jackets getting mixed up and him trying to be systematic amongst the chaos. Poor man, my mother said. We often seemed to do things like that, as if we weren't entirely committed to reason.

Our life was improvised. We had no furniture to speak of, so he hung his black shirts from the picture rail. We decided to start with the garden and trod in a minuscule patch of turf, sidestepping together until it was even and then we decided to get married. The baby lay on a crochet blanket, waving her arms, her pale skin shaded by the washing flapping overhead.

We are standing close and smiling in the wedding photographs and I'm wearing his pearls. But we'd argued that morning because the baby woke early and because I was exhausted, and because he didn't know. His silk shirt got a stain on the front, and I saw him dabbing at it with the corner of a tea towel, his mother looking on.

He only wore his ring once, bothered by its tightness, but it sits safe in his sock drawer. We are linked to each other by a series of fastenings; complications only bind us tighter.

Nine · LOVE

ISLAND

Every day we said we must go to that museum. It was only an island away and we didn't have much to preoccupy us, for the days were long, each hour slowly enfolding itself into the next. Still there was time to go, there was always time to go, but we didn't want to leave – were rooted to our own enchanted isle and weary from the constancy of the breeze, for the island was low-lying, treeless, a tundra of gorse and heather and peat bogs spaded over generations. The cool, salty air swept in from the Atlantic, ruffling the grasses on the dunes and flapping the washing and blowing the curls from her brow as we walked along the deserted beach, with its sweeping ribbon of sand edged with waves of lace. Behind lay the dunes and then the machair, fertile and alive with birdlife, for we had arrived at the height of the breeding season and the chattering and wooing mixed with the sound of the sea and the wind, and tossed our words up into the air as we swung her between us, saying *Again?*

Every night, a creaking and rasping enticed us into the garden, its call an ornithological siren, the birder's tick we couldn't have, for hearing was not the same as seeing. And beyond, the ruins of the black house and the abandoned granite cottage next to it that had preceded the building of ours (it was easier to leave them be) threw faint shadows, as day edged towards a night that never really came, and dusk stretched into the early hours, and the sky still held shreds of blue,

even though the stars were out. He lingered, maddened by the corncrake skulking in the nettle beds, and I went upstairs, pulled by the child's cry, and watched from the window, and the silence of the house and its slow ticking clock was a refuge from the strangeness of the night, and when I held a mirror to her breath, I found in it a reflection of the moon.

We had been expected. What happens if sickness falls, I'd asked, and the landlord said the air ambulance would have us to Inverness in no time. In honour of our vulnerability we were invited to the doctor's house. It overlooked the sea with stony grandeur, and he met us as we parked, eager to see the would-be patient, and as we took high tea in all its Highland formality his eyes flickered to her, and he told us he had come from generations of doctors, fathers and sons guided by the same moral compass. I saw how he was king of the isle and how right that would be if learning meant knowing when to act and when to wait for time to heal, and sensing when life would come and when death would follow, even if those two markers were far apart.

Thirty years later, the man I married stands in the bedroom, paused in dress, and when I ask what he remembers, his lyricism is a surprise. He tells me how we searched for a snowy owl on the moor and, against all odds, found one, a white dot in the landscape, and how there were no red-necked phalaropes – the island had been one of the last strongholds in Britain – and how we passed fields of barbed wire that were full of unexploded shells, and how the doctor had a collection of orca teeth that he found on the beach. But then we often remembered different things. I told him about the shearing, and him holding the sheep down with his knee, and how soft and white the underside of the fleece was. I said, did you remember me writing letters home and going to the shop to post them, and

he didn't, but then I'd forgotten it was the European Championship – was never really that interested, although it gave some structure to the days. But we both remembered the island shop, and the lack of fresh vegetables for her tea, and how we thought there might be oysters or crab or fish, given the richness of the seas and the fishing boats in the harbour, but it was all sent to the Continent in refrigerated lorries. And we both remembered the church sale and the hand-knitted cardigan we ordered, saying we didn't want pastels, for she was pale enough already, but a dancing pattern of blue and red and white, and how we put it on her and buttoned it up tightly against the wind. I was touched that he knew we still had it.

Inexorably, the days and weeks passed, and the evenings waned, and we never made it to the museum. By the time we left, the machair was deserted as the birds had raised their young and started their return migration. For once the night became still and quiet from the incessant wind and the next day brought the midges in and summer was on the turn, and we too turned southwards and nearly died on a mountain road back on the mainland, facing off two lorries that were racing towards us, side by side. We veered off the road onto the rough crumbly verge, wheels half on the hillside, and bumped and skidded and the lorries passed, and my face was drained and she was still asleep in the back, and I knew that he had saved us. But we both choose to forget this memory. Instead we recalled how, as we left the house for the last time, the corncrake flew up into the air before us, wing feathers outstretched to the sky, and it was smaller and more delicate than I'd imagined, showing us that his search, and mine, had not been in vain.

OVERDRESSED

When I pulled off the hat with its bright stripes and earflaps which, without prejudice, was adorable, her fine black hair stood on end and her cheeks were red and she reminded me of an eighteenth-century doll. We had some of those in the collection. I wanted to show the curators how charming babies could be in company but had overdressed her and the journey had taken too long, and she was solemn, as she could sometimes be. I wanted to give no indication of the mornings spent sifting through piles of washing, the unopened letters on the kitchen table and me standing over her cot and monitoring the pinkness of her fingernails, weighing it up until we knew it was time for what the hospital cheerfully called a top-up.

The ward became as familiar as home; it was where her fragile red blood cells were enriched with someone else's, the better to flush her skin, tint her lips, help defend her against infection and malady and other troubles of that kind. It was where she was watched over by the night nurses when we slept on the floor, worn out by the heat and the worry, and where she learnt to love the rituals and attention and cartoon plasters and, when she was older, wanted to go when things went wrong.

Things didn't really go wrong during the visit to the museum, even though I was worried she would object. I know this because I have a photograph of her sitting on someone's lap with her hat and her red cheeks, her big sister alongside her; everyone

is smiling, like curators do when someone comes to visit but hopefully doesn't stay too long because they need to get back to their objects. I once heard it said that babies had no decorum, but everyone agreed that, on this occasion, she was a doll.

FLANNEL

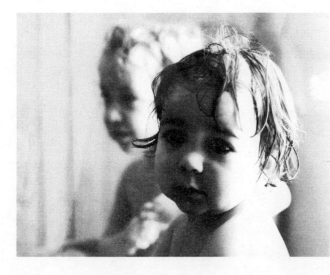

When we were all younger and didn't know what to do with the long afternoons, I'd put the children in the bath. It would take so long to fill that the taps would be left running to keep the water hot. We couldn't get around to finishing the bathroom and, besides, they liked sponging the unfinished plaster walls, the surface taking on a dark bloom that would linger for hours.

Sometimes they would get out and I would get in and say, you can wash my hair if you like. Their fingertips dancing on

my eyelids and stroking my forehead would make me drowsy, and I'd cover my face with a flannel as their chatter became faint and the room filled with steam and the window darkened, and my limbs weighed heavy in the water.

The floor was awash, the toys scummed with grey and the girls' skin wrinkled as I wrapped them in towels and sat them on the chair, just as I had been as a child, and they squirmed, their wet hair flicking drops of water when I tried to kiss their necks, and their pyjamas stuck to their damp skin as we opened the door and the cold air rushed in.

I'm lying in the bath, just like Frida Kahlo in her painting *What the Water Gave Me*, with its fragments of memory bobbing on the surface. I see that my feet are veined purple with the unwanted anklets of age. I lay a flannel over my face and breathe in the humid air and imagine the three of us together again, safe in our watery playground.

FAIRY WINGS

We walk down a long corridor, its low ceiling hung with heating ducts and pipes and untidy lagging, like the underbelly of a vast, primitive machine. Plastic doors like giant flaps of skin lead into unknown areas. I suspect the morgue might be down here.

The photographer's studio is empty, except for a square marked out in white where we have to stand, me holding her. It is over quickly, face first, then left and right profiles, then the leaning in for the detail. The flash makes us jump. I want to say, isn't she lovely.

It had started with a soft swelling and the doctor feeling it with his fingertips and saying we'd better go to the hospital, and me thinking surely the fates couldn't have found another way to scare us. We emerge dazed, having been sure he would say it's nothing.

The surgeon is grave; it's an infection that will not go away. They ask questions about birds. I had let her pick up a feather in the park, and I keep washing my hands, trying to erase the guilt. The sink is black, our concession to style, and I can't see where the dirt lies.

We stick more tape onto her warm skin, afraid to look underneath the gauze. An operation is risky. They are consulting colleagues far afield. I go on my own to see the specialist and say I've overheard something. It's not that, he says.

I photograph her in the garden under the pale pink blossom

of the cherry tree. She is wearing fairy wings and looks up from underneath her lashes, shy and pleased all at the same time. The dressing on her face is bright in the sun.

A nurse drops by; I am not sure who she is more worried about. I fill in a form and we get an allowance for our trouble. The geraniums in the window box begin to crisp and fade. The leaves snap off, sapped by the cooling air of autumn.

I think I can see the swell of her cheek lessen, as if slowly deflating. A molecular battle is going on. I wonder about the scientists in white coats who brew the antidote to our despair. Someone says she is famous.

Today, her cheek bears an indentation with a faint cross in the middle, as if touched by a saint. The fairy wings got bent and were given away. The front door slams, and as she flies down the street I call out, be careful.

Ten · GATHER

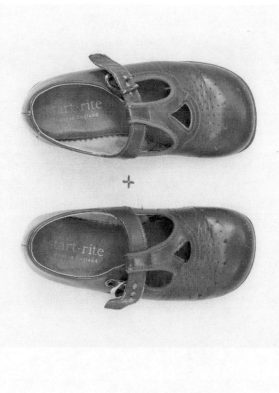

TIGHT SOCKS

My uncle lived with my other grandmother. They had a council flat in Pimlico on the thirteenth floor overlooking the river, near the square where I was born. We played in the cabbagey lift, pressing the buttons and riding all the way up to the top and then back down again.

There was a playground, because people in flats didn't have their own gardens. My uncle spun me on the wooden round-about. I held on tightly to the cold metal bar but lost my grip and landed in the sandpit. It was called centrifugal force, but best not mention to your mother, he said.

He worked in an office and collected pencils and balls of elastic bands. He sent us articles torn from magazines with the good bits underlined and used old envelopes and fixed them with brown tape. He addressed them very firmly, going over the letters with his biro and adding little curls to the ends.

They had new wallpaper and he added some extra touches which took an age. My grandmother didn't mind. She made me toast under the grill but only cooked it on one side. There was a balcony outside where we weren't allowed. Look at her geraniums, my uncle said.

My grandmother thought my mother should have married my uncle. But she said my father would be all right. After my grandmother died, my uncle moved to a smaller flat. I was older then and wanted to help. We went to the King's Road

to buy some lampshades and he took a tablet for his anxiety.

My father had been ringing but got no answer. My mother said, poor boy. Everything was covered in dust, and the armchair was piled with cushions that I lifted away one by one, wearing rubber gloves. I put them carefully into a bin bag so I didn't breathe in the particles.

My uncle's shelves were full of books on science and tapes waiting to be watched. He used to record the Open University but could never catch up. His schedule slipped, and he gave up on Christmas but always sent us office calendars, exactly the same one every year.

He used to stand on a box at Speakers' Corner with his sleeves rolled. He was a socialist and wore leather sandals because they were healthy. He said my socks were too tight and that it was bad for the circulation, and that was why he had to cut the elastic, even though it made them fall down.

RED SHOES

I knew exactly what was in the laundry bag, with its stiff checks and cheap broken zip. There, folded on the top, was the blanket. The wool had felted because I had put it in a too-hot wash, torn between needing to feel that things were clean when germs seemed a tangible threat and knowing that really it needed hand-washing. I pushed my fingers through the holes that the crochet hook had danced around, stretching the fibres and remembering how they too had entangled their small fingers through these absences as I walked up and down our street, longing for them to sleep.

Under the blanket were romper suits with white collars, the type bound to get stained with baby food, old-fashioned cardigans they never wore, minuscule socks and a pair of pink tights that I hadn't been able to part with. Maybe it was from the memory of trying to catch their dancing legs and hoping that foot would find foothole by gravity alone. My mother stored the clothes for me, first in a chest of drawers in the spare room, and then in the garage. I washed and ironed them, knowing it really was the last time, and we polished their red shoes until they gleamed. The girls were briefly interested, less so than we had thought: our attachment to their baby clothes, without them inside, seemed inappropriate, as if we'd got the wrong idea of love.

THE GOWN

Files and papers filled the shelves and the wall was covered with Post-its. She was trying so hard to remember everything. I slept on the floor in the space between her bed and the desk, dreaming that we were at sea. I didn't want to leave because of the dark river that rushed past her window towards the weir. She thought it was a feature but I was chilled by its strong, cold currents and the latch that opened too wide, and couldn't understand why they'd put her there.

In the morning we went through her notes. She stood there in her black gown, symbol of her cleverness, and her eyes were blue and her face was pale. She said, can you hear the moorhen? It's made a nest. I thought of that fragile cluster of twigs and leaves clinging to the wall and wondered how it could hold fast against the pull of the water. When she'd gone, I washed up in the tiny bathroom and then I waited, listening to the chicks call out for their mother.

ARRANGEMENT

Her skin was powdered white and her brace gleamed when she smiled, and I thought of how it was slowly pushing her teeth into place, forcing them to conform. She was wearing a tutu made of black net and coat-hanger wire that bobbed when she walked, lace-up boots, with towering platform soles, and striped tights, like a night-fairy. I didn't know about this kind of fashioning when I was young but would have liked its drama; the dark nails and lips, the corsets and velvet dresses, and the vampiric, raven-haired boys.

At the dental hospital, a group of students stood gathered awkwardly as she lay in the chair, jaws X-rayed and teeth photographed from every angle. Some had to come out, there were too many, the specialist said, and the canines were impacted, growing in the wrong direction. It was day surgery, but when she emerged she looked shaken, her lips swollen and bloody, and as the days went by a delicate tattoo of spider veins and bruises bloomed on her shoulders. I think someone had had to hold her down.

We were having a sort-out. A decade had gone by. She hated going through old things and preferred to leave them to accrue, an archaeology of her young life. Just one box, I said, I won't ask you to do any more. The water in the snow dome had evaporated, and barely reached the top of the Chicago skyline. Travel cards, hair ties, silver rings, concert tickets. Then, at

the bottom, a plaster cast of her teeth. There they were, all in a muddle, overlapping and congested. She looked up and said, that's disgusting, and then smiled at me, perfectly.

CONDITIONED

I can hear the sound of the machine thinking before the drum begins to pick up speed for its final spin, sucking the soapy water from the load and expelling it through the drain to add to the gallons of grey water that we launderers discharge every day, and that swills through the sewers and recycling plants and then onwards to the rivers and the sea, carrying microscopic particles of textile and chemicals and plastic and hair and skin; a little dash of ourselves to add to the confluence before it's returned, refreshed and sparkling, to our taps and sinks and kettles. The powder dispenser is a disgrace and I hope the clothes aren't being tainted by the blackened traces of conditioner that never gets rinsed away and have a go at cleaning it, without enthusiasm. But here the washing is: a damp tangle of parts that I have to refashion. The shirtsleeves have tied themselves in knots and all the small things are hiding inside the duvet cover that I forgot to button up. I pile everything onto the drying rack, which nearly sinks to the floor with the weight. I feel a moment of instability myself, realising that I'm conditioned to wash anything that's not where it should be, but can't find a single school shirt or hoodie or pyjama bottom, even down the side of the beds, because the house that I have so thoroughly scoured is empty; once I bewailed the flock of socks that circled throughout our house and that would not be matched by stealth or system, but now there are only my things in the wash, a clean giveaway of my state of solitude.

Eleven · SENSATE

TOUCHED

Someone I know well reads objects through his hands. He picks them up, turns them round and over and upside down and back again. He does this absent-mindedly, automatically, feeling the feel of vases, plates, cups and cutlery; napkin rings and bottle openers, lids and ladles, the type of all-sorts you would come across at dinner tables. Maddeningly, he can even fathom things that are disguised, however cunningly we try to wrap them up.

But recently he was floored. We could hear him exploring the package from end to end, and all the way round, systematically, like we scan a book, or map out a route, but this was encased in thick plastic, the sort that is used to protect the blades of garden tools, and it had no give. His fingers seemed to have become short-sighted, and it threw him. He came and stood in the doorway. I couldn't read it, he said.

One of my earliest touch memories is going with my parents to visit an older childless couple, and the ceremony of my mother's friend going to get the button box, and being sat on the floor in front of the fire, sorting the buttons into different shapes and colours. In fact, I remember it every time I go to my own box of buttons.

Today, I have no time to sort buttons, but know what they will feel like if I do: my Marks & Spencer jumper with its glossy black buttons that I wear all the time; the hard round buttons of the children's Mary Janes; the glass buttons on the vintage frocks I used to wear; the plastic buttons of my gingham school dress; the toggles on my first duffel coat; and, going way back, something I had known in my fingertips but forgotten, a far-away memory in all this remembering of buttons, of sitting on my mother's lap buttoning up her cardigan, and pushing each button through its buttonhole with very small fingers. I like to think that this is my first memory. I was buttoning and unbuttoning her all the way up, and then all the way down again, just as she had shown me, and we were together in this ritual, practising the art of the button.

MIMESIS

The Delphos gowns lie in the mahogany drawer, coiled into fat rolls to stop their lustrous pleats from falling out, just as they would have been kept in Mariano Fortuny's showroom in the Palazzo Pesaro degli Orfei in Venice a century ago; for these were the years of art-dress, infused with exoticism and impracticality, worn by film stars, society hostesses; those of an artistic disposition.

The dresses were formed from narrow lengths of the finest Japanese silk, hand-stitched together and then pleated into rills like the delicate underside of a field mushroom through a mysterious process involving heat, ceramic rollers and water, to create a shimmering, clinging tube of impossible lightness and loveliness that pooled at the feet and that was Grecian in both form and intent.

Murano glass beads suspended on strings of twisted silk dot the shoulders and seams and weight the skirts to stop their fluttering, while the pleats skim the swell of stomach and curve of hips in a heavenly palette: crushed marigold, Tiepolo pink, silver-grey, teal, salmon, pale blue, ivory and black. The most expensive are dusted with gold; stencilled with Greek key patterns and medieval fleur-de-lys.

It was my favourite cupboard, and I always opened it for visitors, drawing the layers of white tissue aside with a flourish, offering up the most marvellous tonic to the senses for those who were jaded by fashion, engendering sighs of desire and regret for what could have made caryatids of us all. *Faithfully antique but markedly original*, wrote Proust, with literary exactitude.

FASHIONED

It's a series of envisionings, I explain. I was referencing the high-gloss, art-meets-fashion magazine *Visionaire* that the National Art Library collected (it was very expensive) and that had changed the way many people, including me, thought of fashion – transforming it, in my mind, from a discipline that on the one hand offered mass-produced, conformist street wear, and on the other, high-end, out-of-touch couture that nobody I was likely to know would be able to afford or even want to wear. Instead, it proposed a third way: fashion as an expression of artistry, veering on the edge of non-functionality, with a heightened aestheticism that owed much to preoccupations around identity and expressiveness – the wearing of clothes as an art in itself – and that had its roots in the emergence of the Japanese wave of designers in Paris in the 1980s, whose rarefied clothes, asymmetry of cut and fascination with both technology and history shocked the catwalk.

Opacity and opalescence collided, heaviness and weightlessness took on new properties, exchanged attributes – resulting in the framework of clothing expanding to take on unusual forms, unseen-before silhouettes, raw edges, with tacking stitches left in, a no-fit philosophy, throwing emphasis on form and drape, and proposing that the space between the body and the cloth was as important as any external carapace; that sleekness and perfection was old hat, and above all that proposed a

predominantly black palette that was somehow both punk and futuristic, archival and unravelled. This met, headlong, the energy coming from the clubs and streets and art schools of London – the triumvirate of Westwood, Galliano and McQueen, a wunderkind for every decade, sharing a fascination for historicism and a compulsion towards modernity – nostalgia for the future, as Westwood put it.

To all this came, it seems suddenly, the Internet and all the possibilities inherent thereof. And this was all summed up in a single image taken in 1997 that had been on my mind ever since, of Japanese model Devon Aoki in a McQueen (the new pretender) silk brocade dress like a cybernetic courtesan with her sightless, opaque, contact-lensed eyes and a safety pin (punk-not-punk) entwined with cherry blossom piercing the skin of her forehead. This unearthly image by photographer Nick Knight became the leitmotif for the exhibition that we couldn't name, for he was the conduit: conductor and interpreter and freeze-framer and stage producer at the vanguard of fashion, producing images that demanded magazines with the ambition to live up to his artwork in terms of reproduction, paper and feel. Art magazines, in other words – for despite this new digital age, the magazine was still king, for where else could we see these compositions, envisionings, as the last century began to wane and the new one loom?

* * * *

It is my first exhibition in the museum, after my ad hoc venture *Fashion in Motion* (an ambulatory affair involving nervous curators and creatively dressed models). An entire roomful of people discuss titles, with representatives from every department, because to name things is their job and mine, and if we

get it wrong, people won't come. A title needs to sum up an exhibition in no more than three words, plus perhaps a subtitle. If it can't be done, there's something wrong with the thesis, and so, in order that I can progress, we need to make a decision. This is what I said:

We step through an eye, as if we are travelling into the mind of the designer. An ambient soundscape fills the air; the sound of a ship creaking as if we are voyagers; ice breaking and re-forming. Frocks hang from the ceiling, showing us their underskirts, which unfurl into fuchsia-like flowers then shatter into a thousand shards before reassembling, digitally. Dresses spring from boxes under their own volition, like Christmas lanterns or fabric origami, glowing as if lit from within. Models on an endless catwalk walk towards us, disappear and then start walking again. A dress is reflected a thousand times in a thousand mirrors. A glass vitrine holds a glass dress, made of bloodstained microscope slides. A wooden crate addressed to the museum lies unopened. A vast bale of fabric rolls out an unending tube of tubular garments; it can't be stopped. The curved seams of a dress undulate with fever. Dressmaker forms stand on a chessboard and, when I turn around, they have moved. I see a small figure dressed in black at the top of a ladder. He's got a curved needle in one hand and he's stitching a woman into a dress that is so tight her body has become compressed, extenuated. It's fashion and it's radical.

Twelve · CURATOR

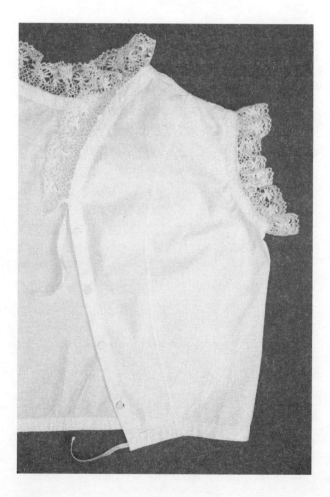

WADDING

The mannequin store is underground along a low corridor with locked doors leading to stores and plant rooms and places where difficult things are kept. The mannequins are difficult. As we try to move them, they swivel in their sockets, pulling away from the spigot that holds them upright, and I hurt my back trying to lift the metal base from a crouching position. The store is too crowded, that's the problem. The mannequins are taking up the space where we want to be, and we have to move them one by one, to get to the shelves.

I climb to the top of the ladder, looking for a head. Stories about a ghost curator have been circling the museum for decades. People have heard tapping at the doors, but when they are unlocked, no one's there. I've left ours propped open, and still I'm nervous, impatient to be gone.

Some of the figures have their waists hacked away and are encircled with wadding as if hiding some terrible wound. A file has been taken to their breasts too because it would be inappropriate for a nipple to mar the bodice of a nineteenth-century gown. The mannequins are all shapes and sizes, just like our garments. We don't fit clothes to them or alter the garments in any way.

Most of the wearers are dead now, so we work out their proportions by emulating every particularity (for no one is symmetrical) based on the interior indentations of the gowns;

a pressing of flesh on fabric here, a seam taken out there, the rubbing and the pulling. It's just wear and tear, the friction of age, but it leaves us with vital clues for our ghost bodies.

* * * *

Sometimes people ask if we are tempted to try things on, and we shake our heads, we wouldn't dream of it. But I did, once, dream of it, as I slipped an ermine coat off its hanger and felt the cool fur brush against my cheek. It would have been so simple to put my arms into its folds and feel its extravagant cruelty. I think of it still, imagine its weight, the sly sensuality of satin and fur and skin.

But for now, we have work to do. We load the torsos and the arms and legs onto a trolley, and wheel them down the corridor, their feet sticking up awkwardly. In the hospital, I was always surprised to see the ill paraded in their beds, the vulnerability of crumpled sheets and drips, and felt there should be a private corridor for such journeys, away from the curious and the walking-well bearing clouds of germs around their heads.

I think of that as we trundle along the back route and go into the galleries. Visitors glance at our dismembered set of parts. Once, we used to be shut on Mondays, and the museum became a day-long hive of activity, with objects transferred here and there like luggage at a railway station. Now, early risers complete major complicated moves involving sculptures and altarpieces and cumbersome things before the museum hums into life.

More modest journeys are conducted in plain sight. I see two curators carrying a deep basket with leather handles at either end, 'CER' printed in bold black letters on the side. They are almost swinging it, but not quite, so confidently do they

stride along, chatting to each other. Inside, priceless ceramics lie cradled in tissue, a Sèvres figurine perhaps, or a Meissen cup and saucer, painted and gilded. If only the visitors knew.

Under pressure to finish the display, we glide our figure in its coating of white tissue past the restaurant. One of us walks ahead, clearing the way. No one thinks to touch our arm to say what are you doing, because we are moving fast, so fast that the tissue flutters, showing glimpses of silk and satin and embroidery and gold work, and hinting at the shape of the gown, its fullness of skirts, its *importance*.

Like hospital porters, we have a job to do, a place to get to, and there are no private tunnels, except those that lead to dead ends and haunted storerooms. We transfer our cargo from packing case and bed, gallery and ward, stitch them up, rest them, wheels turning over marble and linoleum, skimming past us while we turn away from shame at being well, and fear that weakness, age, frayed and shattered seams will be contagious.

Both institutions are reminders of endings, of time creaking and shifting, of entries and exits. We feel relief at breathing the fume-filled air of the outside world at the end of the day, at managing to escape the storeroom and hospital ward, to feel blood coursing busily through our veins. We have one more thing to do, to sort out the scattered limbs lying in the storeroom. But it's late. We'll leave it for another day.

PRODUCTION LINE

The young man wore a tightly fitting dark blue suit and white shirt open at the neck, and drove very fast, caressing and drumming the steering wheel with his fingertips, gesturing in disbelief when other cars impeded his progress, talking on his mobile phone as if his impatient senses and sinews needed to multitask lest he expire of boredom. I sat in the back, tense with nerves, in-between my colleague and the beautifully dressed representative from the fashion house who was looking after us. I was a mother and didn't want to die on a motorway far from home. The next day we were given another driver and our progress was stately, dignified; the company was kindness itself.

We went to the factory every day. It was an hour from Milan in an industrial area that seemed out of keeping with such a luxury label, but even luxury labels mass-produce some of their ranges, their accoutrements and accessories, and this was where those companion pieces were designed and made, inside a windowless hangar of a building. The lighting in the factory was harsh, and rows of machinists sat bent over their threads, while distorted pop music played and vast digital printers disgorged patterns for the cutters and all the while, above the shop floor, white shirts inched their way forward on a moving rail to be folded and secured with plastic clips, wrapped in

cellophane and neatly boxed. They were journeying to the packing department and then the glossy arcades of the city.

We'd had a tour of the fashion house itself, replete with classical statuary, gilded chairs and contemporary art, and marvelled at the combination of restraint and luxury that characterised the family firm, as if it was ancient by principle – championing craft and graft – but late twentieth century in its embrace of consumption as a rightful art. The haute couture workrooms – in the tradition of all haute couture workrooms situated in the attics to benefit from the light – overlooked a sequestered, tree-lined courtyard, where the fashion shows were held. Here we saw white-coated dressmakers tambouring beads and sequins onto taut lengths of chiffon, their fingers moving even as they looked up to smile. Others were assembling complicated fragments over dress forms, pincushioned wrists dancing about the gauzy fabric, coaxing it into place. At the time, we weren't allowed to take photographs and I say this freely now, because today such houses often reveal their inner workings. The *petite mains* are the heroines of the hour, invited to take bows on the catwalk. Everyone is interested in the romance of labour, the archive, the curation.

This particular house's archive was kept in a glass-windowed box at the top of the factory, up several flights of clanging metal stairs, hung from the roof like a foreman's office on a building site, and with that same temporary feel. Inside were tightly filled rails, each garment covered in a plastic cover that seemed to attract rather than repel dust. I hadn't done my homework and didn't know where to begin; many of the pieces seemed inexplicable, meaningless without a body in them, but gradually, over the days, I began to understand. Although high-end

luxury Italian power dressing, with the glossy kind of grooming that goes with it, was so remote from my lifestyle it was laughable, I found peace in my little eyrie, became absorbed in the fabrics and the stitching and embroidery, respectful of the drama of the gowns, the mastery of soft leather, the button-holing and the beading.

Just before the exhibition opened, I was filmed looking at a wisp of a dress lying deflated on a table in our storeroom. The chiffon was printed with leaves and fronds and had been worn by a supermodel on the catwalk. It was not so much a garment, more a suggestion of a garment that was entirely reliant on the beauty of the model's body. I was at a loss for words, because normally I would talk about structure and seaming and silhouette and cut, but these wisps of fabric had more in common with beachwear, the garment's wings specifically designed to open and flutter and reveal the honed body in motion and the ethereal beauty of the fabric. Recently, the design was shown again on the catwalk, twenty years on, by the same supermodel, brave in her maturing body. It struck me, looking back, that my education had, in this case, really been about a country that imbued the labour of fashion with dignity.

APPLE PIE

I got a bus after work and ended up somewhere between Paddington and Notting Hill Gate in a basement flat that was so untidy I didn't know where to put myself. I stood awkwardly and then asked if I could move some papers off a chair. My host gestured with nicotine-yellow fingers and we sat in silence. I knew it was important to my subject that I meet him before we embarked on the exhibition but didn't know why.

She arrived on her bicycle soon after with an apple pie that I looked at for a very long time before realising I wasn't going to be offered any; that I had to help myself. Bourgeois politeness had no place here.

The flat was lined with books, and I listened while they discussed the death of culture, and their plan to create a literary salon, based on the elite social space of manners, etiquette and seduction often ruled over by women in the eighteenth century (she was a Francophile). Once or twice they asked if I'd read a particular tome but carried on before I could reply. When I left it was late, and I was hungry and disorientated and felt a certain kind of despair to do with feeling out of my depth, of having taken a wrong step; with no aptitude for fashion and finding myself with people who I didn't understand. But I seemed to pass the test, even if my notes from that evening were incomprehensible.

I got my own way in the end, I think, because I worked so hard. That much we had in common. I bought every book she remarked on (none were about fashion – these she nonchalantly dismissed) as well as reading all her interviews. She was an easy target for the press because of her earnestness and parabolic sentences, but perhaps her obliviousness was helpful. She simply ignored slights and kept going, concerned to get her point across. When we spoke, it was as if I was hearing unravelling spools of thought, and I would lose my way. But when I transcribed my recordings, what she said seemed to make sense; possessed conclusiveness. It increased my respect for her.

I spent two years listening. I learnt about fashion through the particularity of her eyes, about punk and protest and her role in it, about the serpentine profile of the bustle, the dynamic of the curved seam, the sway of the crinoline, how in fact the corset offered support and freedom. I learnt about the rustle and crumple of silk, of swagger and certainty, and about how *you have a better life if you wear impressive clothes.* I looked at her luminous skin and realised there was a beauty in the way she was ageing; it was more than physical, it was cerebral. It was about not caring at all what people thought.

I saw her recently, after many years, at a memorial service for my Keeper of old. She didn't seem displeased to see me. She was wearing a long, clinging dress that velveted her spine and the pattern reminded me of a hummingbird's wings. I asked to touch it and she didn't mind, and the pile was so soft my fingers were barely able to register, as I imagine a hummingbird's wings might feel, if stilled. The only problem, she said, is that the fabric does ride up, and I heard the practicality and the burr in her voice, just as I'd heard it soften all those years ago when I said I liked her apple pie.

FOIL

(For Adam Phillips)

In his art there was a certain amount of borrowing. Sometimes he liked to incorporate parts of wild animals into his clothes, for example, placing dried baby crocodile heads onto the shoulders of a jacket so that they looked like snapping epaulettes. Once he fixed a curved tusk so that it burst through the back of a coat, like a phallus. Using animal parts brought a frisson of danger to his work. On the catwalk, he dressed his models, and applied dark make-up to their eyes, so that they themselves resembled predators, and sometimes prey.

The models who worked for him spoke of how he incited and allowed them to perform, to take on a role appropriate to that particular collection. For his collection *It's a Jungle Out There* he encouraged them to feel feral. To growl and snarl and prance, with their false horns and matted hair, carrying the body parts of wild animals on their backs. He'd take an armful of fabric, a pair of scissors, scurry around his fit model, and start to construct: draping, folding, pinning, cutting, ripping off, starting again. This is completely common practice. Lots of designers work in this way. But when I saw a clip of him wrestling with the horns, he seemed to be wrestling with the idea of scaring off something by keeping it in the mind's eye, keeping it in sight, and the catwalk was the perfect place to do

it. This is not to say he wasn't concerned with aesthetics; it had to look good too.

In *It's a Jungle Out There*, he used the colours of the savannah, dried-out browns and yellows, rusty reds and dirty creams, and, in one case, strings of faded wooden beads about the bodice of a dress. This dress intrigues me. It's made of cotton, but the hem has been dipped in latex, giving it an unpleasantly fleshy feel. He discovered how to use latex when he was experimenting as a student. He tipped some away and it solidified and took on the shape of the drain. Poured over a textile, it took on the qualities of fabric – mimicked its movement, but sluggishly.

This is what makes his art so different. It seems unexpurgated, emotionally. Of course, there is the functionality of his clothing, the marvellous fit of his tailored trousers and jackets, the desirability of his daywear – in the mood, he could conjure up the sweetest of dresses (although these were usually hidden by the theatricality of his collections, they were invariably spotted by buyers and suchlike who could see through all the fireworks). He was well known for achieving both drama and commerce, and the more outrageous pieces surely acted as a foil, a method of distraction, rather as a plover will feign a broken wing to draw predators away from its brood.

Just so was his method of handing over the way he was feeling to another part of himself, the showman, the virtuoso tailor, the imaginer of vast, dark bird-women, snaking like sirens, to gain all the attention on the catwalk. Perhaps the reason why his work remains so powerful is that he invested a little more than most designers. The quiet, commercial numbers have a bit of this – after all, when you are buying from his house you do want a touch of menace, while the unfettered showpieces which were never reproduced live on in museums

now, like rare birds. Perhaps he hid what was of him amongst the seams and stitches, the hems and godets, the latex-dipped dresses and the snapping epaulettes, hoping that bluster and stagecraft would protect him.

TOO LATE

I could hear the sound of the doors being locked, one by one, and footsteps coming closer. I kept still, my head down, the only light in my office coming from the computer screen and a desk lamp in the corner. Time passed – an hour or so maybe – and I fell back into my work, my struggle with words, my attempt to remember what I knew and what I needed to know. Open books lay all around me, I was checking my facts, working

on my labels. When I turned around, the entire floor was in darkness and I began to feel uneasy.

The galleries had their blinds pulled down, an uncharacteristically domestic touch, like the bottles of milk left every morning outside the wrought-iron doors of the side entrance – who for, I've never known. The museum was silent, the lighting dim, and I wanted to linger, to feel once again the privilege of being alone at night in this vast emporium to taste. But I was also nervous, and walked quickly, my steps ringing out, eager to emerge into the late-night traffic, to share a homebound bus with other tired travellers.

I went through the Silver Gallery, with its gleaming punch-bowls and elaborate candelabra. Below I could see the courtyard, its elliptical pool glinting in the moonlight. There was a moving beam from a window on the other side. A warder doing the rounds, I hoped. I was not supposed to be here. This was the time for spectres to stroke the brittle folds of dresses, to open creaking wardrobe doors, to leaf through musty volumes, try rings on their skeletal fingers, and regard their absent selves in darkened mirrors. This was the time to drink ether; raise high the goblets of bright silver.

Thirteen · SEAM

THE PRAM

Our garden was square, with a path running around it. There was a rockery where pink geraniums grew, and the washing line with plastic pegs and the pear tree with a hole in its side that for years I wasn't tall enough to see into. In the summer, rotting fruit lay scattered on the grass, and my brother stepped on a wasp and cried. At the far corner was the shed where the lawn-mower lived. We weren't allowed in there because the tools were sharp. Behind, was a narrow, dank passageway. We dug a hole in the ground and weed in it.

Next to the shed was the pond. It was full of tadpoles, and when I picked them up their tails licked the palm of my hand. Further along was the compost heap. We put our hands on it, feeling its musty warmth. My father turned the crust over with a fork, revealing its sickly green underbelly. We jumped into a great pile of leaves, swept up by someone we had never seen before who told us off; he never came back. Our parents were always on our side.

At the far corner there was a vegetable garden and two cooking-apple trees. A hammock hung between and I wrapped myself up in it and could see specks of light through the holes in the canvas. Then, completing the circuit, the sun-filled courtyard. It had a door inset with Victorian glass and when I was inside looking out I could make the garden red, then blue, then green. Above was the window to my mother's bedroom.

She would leave the curtains open at night so she could watch the planes slowly crossing the sky.

I fed my dolls with a plastic bottle and pushed them round the garden in their pram. My mother would sometimes brush their hair, smoothing it with her comb. She told me that she had only ever had one doll and that her father had won it at a fair. But it got broken – she saw its shattered face in the bin. She told me that story all her life.

We were on the high street and I was holding her hand. There was a big pram with its hood up, but when I looked in there was no baby, just a long, wizened face with closed eyes. The blanket was drawn up close, and the old fingers rested over the edge. At bedtime I was afraid and went downstairs. She knew why; hoped I hadn't seen it. I knew she was sorry, and her gravity both consoled and alarmed me.

DRESSMAKING

When I was very young, my father had tuberculosis and was sent away to convalesce. My mother would put me in a laundry basket and take me on the bus to work. They had a place called The Handy Shop, which sold knitting patterns and wool and baby clothes and separates.

There was a changing room with a bench with cushions on it and a thin red curtain. I watched as my mother crouched down and warmed the milk on a gas ring. She let me play with a sample book. Each page had fringes of wool shaded by colour and I lay on the bench, and stroked the strands so that they lay smooth and flat.

My mother had a long white scar on her knee. She had been standing on a ladder and fallen through the counter. The counter had a glass top and wooden shelves underneath that slid out and you could see the balls of wool through the glass. Her knees were round and smooth and the scar was soft when I touched it.

She made most of my clothes. She inched around me on her knees and couldn't speak because she had pins in her mouth. I had to keep still. My grandmother won the pools and went on a cruise but had nothing to wear. My mother made her an evening dress from black Lurex. She made a copy for my doll too, from the scraps.

* * * *

We always drove. My mother would keep a bag of presents by her feet. We were allowed one a day. I once got a tiny plastic cot with a doll in it. We made cat's cradles out of string and tied them to the door handles and made the doll go on journeys, and the cot was its boat. My mother made blue curtains for the car, and she drew them when it was bedtime. They kept driving and I heard them talking but couldn't hear their words.

One morning I woke up and we were in a field and the tent was up. We stood at the back of the car and were allowed to choose a box of cereal from a variety pack. The milk wasn't right, and we pulled faces. Look over there, my father said, and we saw a bridge and a walled city, it was gold and that's where we were going. We kept driving. Don't look, said my mother. My father ran back but couldn't help. I saw someone sitting in the middle of the road with their hand on their head as if they had a headache.

* * * *

When I was older, I looked at clothes in magazines. I wanted a circle skirt. My mother said they were easy to make. We went to Goodbans and chose some material in swirly patterns; pink and green and shades of blue. They were for my best friend and me and we got matching T-shirts too. I hoped people would think we were sisters. We cycled around and I fell off but couldn't get up. I had concussion, someone said.

I did dressmaking at school, in domestic science. I made a corduroy dress but, by the time I'd finished, it didn't fit. My mother made me a blouse from flowered silk which my father got from someone in the rag trade. When she sliced it the material moved, and she said dammit. The buttons were black jet, from the tin box, but I wouldn't wait for her to make the buttonholes. I shouted because I wanted to go out and wasn't allowed.

There was someone I admired at work. She lent me a dress pattern, and my mother made a tunic for me, because I was expecting. It was fitted at the shoulders but flared out to just above the knees. It was plain and, I hoped, stylish, and the mother-of-pearl buttons were hidden behind the placket; only we knew they were there. It got too small, so she made another and we choose purple grosgrain. I felt in a state of perfection.

The last thing she made was my wedding outfit. We chose the material together in Liberty's and the linen was so fine I hardly dared touch it. I washed the top and ruined it, but the skirt is still in my drawer. The outfit was based, in a roundabout way, on the designs of a famous couturier, a poet of fashion. Now, when I look at his designs, I think of my mother, and of her inching around me on her knees, and the clothes she made just for me.

WEDDING SUIT

My parents were married on Christmas Eve, over half a century ago. The clothes in their wedding photograph are interesting. My mother wore a tailored dress that she, I am sure, had made herself. It is smart, and the chromatic depth of the black suited her pale skin and short dark hair. I used to boast to friends about my unconventional parents, and how my mother had married in black because she was a socialist.

Although she was always neat, it was my father who was the natty dresser. The last time he came to the museum he wore a pink shirt with cream trousers and jacket and carried his father's silver-topped cane. The pink brought out the colour of his blue eyes.

I had often looked carefully at my mother in this photograph, and her dress and the fact that she wore no jewellery bar her wedding ring, and the way she was smiling at him. I had never studied what my father wore. But recently I discovered that he had been wearing a bespoke suit, and that he had been very proud of it. This would have been so far beyond their means that I was amazed, but for a while he had been a film extra, a man of the crowd, and once, around the time they were married, a double, for he had the same build as the lead. My brother spent a long time searching for him, scanning the crowd scenes, frame by frame, but never found him.

THE WEST WIND

We were standing in the hallway looking up, and my father was upstairs looking down. My mother has died, he said. I felt the balance of the house shift, and the banisters creak. For once, I was not in their sightline. I tormented myself imagining that I had to choose between them, that only one could live and that the other had to die. But the choice wasn't mine. It was about who could resist the gravitational pull of death the longest; about who had the tightest grip.

My mother was remote but constant, the pole star in our lives. When I phoned up from the airport in a fit of nerves, she said that I would be fine, and I believed her. When my father became anxious, she'd take him in hand. But it took its toll. She cooked dinner in her coat when she got in because, if she took it off, she would not have the energy to go on. Tiredness was something she suffered from all her life and, in the end, sleep became her silent friend.

We did her bidding as she raised a frail hand to point to water or to be turned. I combed her fine white hair and she became still, and I did not know which was her last breath. But I knew that it was final, and in that moment accepted that the end really was the end.

I thought the language of death would be replete with inky metaphors and Gothic turns of phrase, but there were none,

at least not in my vocabulary. It was enough to say, just as my father had, that my mother has died.

I read *Let me not to the marriage of true minds*, speaking for them both. I did not know that, when Shakespeare wrote of love: *It is the star to every wandering bark*, bark meant boat, until my father told me. At his own funeral, barely six months later, a death he did not consent to, and nor did we, I read John Masefield's 'The West Wind', shouting the leaf-strewn phrases in defiance. I wish there had been more time with him. I wanted to hear how he taught himself music. I wanted to hear how he sailed on the *Mauretania* and how the band ate at the captain's table. I wanted to sit with him and hold his hand.

We have a black and white photograph of my father in New York, a slight figure in a baggy suit. There, in the city of jazz and art and quick talking, he could have been at home. But he came back across the sea, with his blue eyes and his warm hands and his laughter, and he leavened her solemnity. Together, they made me understand that the slow pull of death is part of life, and that love can last beyond the end.

Fourteen · LOSS

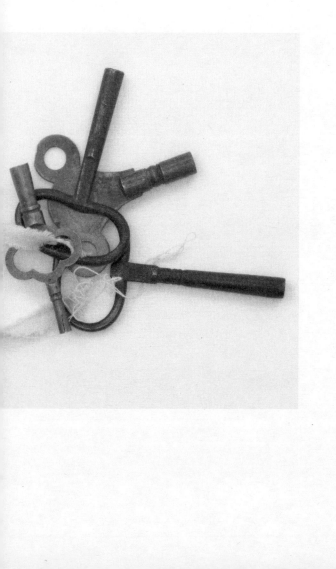

EMAILS

My father had what he called his *day-to-day struggle* room, and towards the end it was a struggle. Here he sat at his desk and laboriously sent emails, pressing down each key firmly, one by one. The messages were short, with random capitals and eccentric punctuation, like telegrams from the edge of life. They were concerned with Socialist Party meetings (he was one of the last members of his branch), the odd email to me and my brother, and a few to friends, often commiserating about ill health. The last one he sent me read:

Claire==Let me have the procedure for the Crumble ,please Dad

It's taken some effort to retrieve it from the archive in a sea of now-meaningless work emails, and it brings tears to my eyes. Was he referring to apple crumble? I don't know, and I can't remember. During the last six months of his life I was so terrified of losing him that I visited constantly, stood as close as I could to his woollen-jumpered self, and held on to his rough, warm hands at every opportunity. As he edged closer to death, I tried to hold him back. I told him to slow down on the stairs because I couldn't bear his shortness of breath. I rang just to hear his voice, so I could sleep at night.

After he died, my brother went to the morgue and dressed him in his finest. He said he looked good, and I can imagine that beautiful body laying still, his blue eyes closed. So much of him still worked, but for one failing part. His plumbing, he called it. I hadn't been able to stop time and, for all my attentiveness, wasn't there when he died, but sitting at my desk too tired to go home. When I arrived and sat wailing in his armchair it felt as if a great chasm had opened beneath me, and all that held the chair and me up was hope against hope that a mistake had been made and that if we all believed hard enough he would wake up and smile, as he always did, and drink his tea, two digestive biscuits on the saucer. We would sit hand in hand and watch the local news as the sun set, and the electric bars clicked, warming our cold feet.

RECOVERED

Every time he sat down a puff of dust would sigh out from the feather cushions. I wondered if it was unhealthy. The sofa wasn't quite long enough to stretch out on, and I arranged the pillows so that his head and shoulders could rest on a gentle incline, and then laid the tartan blanket over his legs, for warmth. He squeezed my hand and closed his eyes. I let myself out of the front door and went home and never saw him again.

The swatches lay on the grubby arms of his sofa and I wondered if it would be cheaper to start afresh but considered the satisfaction of fixing something by re-clothing it, just as we fix ourselves. I thought of linen because it was crisp and light, like a summer walking dress, or velvet because its plump pile reminded me of a gentleman's waistcoat; even silk brocade because its metallic sheen of luxury made me think of courtly attire.

I imagined lying on the sofa, book in hand, and wondered if I should instead dress its cushions and covers to match myself; white perhaps, to reflect my wardrobe of freshly laundered shirts, or grey like my favourite Old Town coat, or black to echo my shadowy corpus of work wear. I liked the thought of the sofa's cladding as a form of self-portrait, upholstery that would befit me, seam for seam.

In the gallery, we teamed rush-seated chairs with Indian shawls, garden seats with tailored riding habits, upholstered

button backs with bustles and bodices and crinolines, and smooth chrome recliners with svelte gowns of satin, cut on the cross. It's not so unreasonable to draw parallels between the held and the beholden, so let me suit that sofa and recover myself; stroke its arms and remember his.

CANVAS

The wooden bench with its saw cuts and cast-iron vice had tools littered over it, as if he'd just stepped out. When I picked them up, I saw that dust had stuck to their oily surfaces, making them seem blurred. There were cardboard boxes with faded labels full of screws and nails, and a delicately tapered saw, like a surgeon's. The wooden handle felt smooth as I put my hand around it and touched the rusting blade with my fingers. I picked up an enormous pair of scissors, almost too heavy to hold, and remembered the sweet smell of pasted wallpaper and the limp folds collapsing on the floor as he cut away the excess, and the way he would brush the bubbles out, and how the paste oozed from the sides and how he'd let me pour the sachets of powder into the bucket, to watch the water solidify.

My father improvised. The rafters bore a series of pulleys and a pair of oars from when he used to sail, and bulky shapes wrapped in canvas tied with blue nylon rope, and the fluorescent light hummed and flickered when he switched it on. I bought him a book of knots, but he had his own special ways. The garage doors were secured with a drop bolt that fell into a hole in the concrete floor with a clang. But the boundary between inside and out seemed more fragile here than in the house, where the front door closed with a muffled sigh, and the taut copper strips that he nailed to the frame repelled any impertinent draughts. Even the inset glass, with its keystone

relief etched a century ago or more, seemed impervious to fracture as if stones and intruders and dangers were unlikely to cross this particular threshold.

But the garage doors had gaps and the sound of traffic traversed through the planked wood, and passing buses and rumbling lorries shook them in their hinges, and made his site of industry seem worldly, a place where cans of beer were drunk, and furtive cigarettes smoked, and where he would sit in his car, listening to the radio, and where I feared finding top-shelf magazines, but didn't, and where he spoke to me once of their marriage and I sensed that he was lonely. And this was where a builder kissed me on the lips and said don't tell your parents, and I, obedient, never did. And this was where I stood in the cold, as the garage doors shook, and the outside world seemed too close for comfort.

THE RUNNER

I placed the pieces of furniture side by side, laid the rugs down and stacked the pictures against the walls. When I pulled out the drawers of a chest-on-chest, they squeaked and dribbled dust onto the floor, filling the room with a sweet, musty smell. I'd not had to empty them for, to my sorrow, my mother had already done so before she died.

Our house settled into a baffled silence. The furniture had the effect of confusing me too, overlaying my life with theirs like a double exposure, so that when I came down in the morning I didn't know where I was. I called in a runner, and we talked about mahogany, and dovetail joints and missing keys and the patina of age, and I liked the tenor of his company.

The notes felt warm and bulky in my hands, although I didn't really want the money. Afterwards, the room seemed expectant as if released from its dark burden, as I had intended. But as time went by, I mourned the faded rugs and the missing furniture and what had once been contained in it and wondered what else is lost when we lose a house.

Fifteen · DUSK

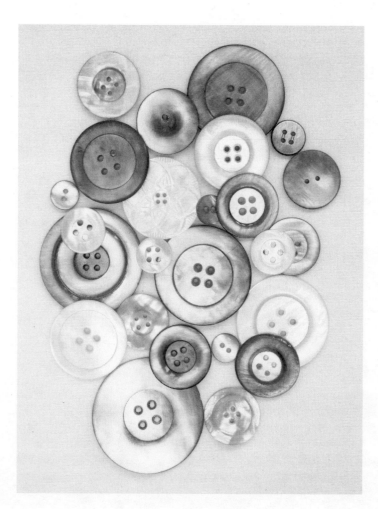

FOOT-SURE

We were sitting side by side inside the tent. I saw my school friend's mother take off her legs. They lay on a camp bed, wearing beige stockings and big brown shoes. She was walking around and was much shorter than she should have been. I was afraid of the dark outside. I ran out of clean pyjamas and had to sleep in my underwear, and it got wet and dried again and chafed my thighs when I walked. We've had a bit of a problem with Claire, they said when we got home.

My grandmother said her legs felt heavy. She wore tubular bandages to keep the swelling down. She would sit on a chair and unroll them all the way up over her knees and her legs would go firm and solid, like pretend flesh. Her stockings went on top and she'd put them on carefully because sometimes they snagged. They were slithery and shiny and held up with suspenders that hung down from her corset. I knew this because I had seen it in her bedroom. It was body-shaped and the clips were like little legs.

She had a double bed with a maroon satin eiderdown. Her dressing table had a mirror with side wings and there was perfume on a glass tray. I saw my profile for the first time and didn't know myself. I slept in her bed and her sister slept there too. They talked in Welsh as they got undressed, and I thought they were cross. They took their stockings and their corsets

off and put them on the chair, and when they got into bed, I sank in between them.

My legs are stocky like my grandmother's. I like being connected to the ground; don't like flying. Once I was standing at the top of a hill and lost my footing and saw the sky and the earth turn upside down, first one then the other, over and over. My father ran and picked me up and kept on running. Later, a stranger looked at my face and shook her head. I didn't know what I looked like. I realised that there were two parts to me, my body and my mind, and that sometimes bits went missing.

IMPRINT

(For Circe Henestrosa and Gannit Ankori)

The medical bandages were dipped in buckets of plaster and wrapped around her naked torso in layers which gradually hardened to provide a rigid carapace, immobilising any movement that would undo the benefits of the surgery on her vertebrae and thus cause further damage to her spine; and all the while the young woman – only nineteen – hung by her feet while the plaster was dried with blasts of hot air, so that the bespoke corset – which she would wear for weeks, if not months – would hold true. And once, when this performance was conducted at her family home on the corner of Allende and Calle Londres, the bandages were wrapped too tightly, and as they heated and contracted – as plaster will do in exothermic reaction when mixed with water – the girdle began to compress her lungs and, terrified by her screaming, her family had to cut her free from its grip without recourse to medical shears, for the doctor had left and there was no orthopaedic cast technician with an oscillating cast saw to hand, for it was the 1920s.

These stories Frida Kahlo told about herself with gusto and humour, never self-pity, just as she told many other stories, firstly about the childhood polio that led to a weakened and shorter right leg and how she was teased for this, and then the near-fatal accident that compounded this imbalance and added many more troubles to her stoic body. Her subsequent suffering

and the endless ways she tried to be cured of an injury that could not be cured, at least not at that time, when such operations – and she had many – were likely to do as much harm as good, meant that she was often bed-bound, and here she held court, much in the manner of a queen receiving guests in her bedchamber.

The corsets – there were others, some made of leather, some in the form of back braces ordered in America, where she also sought medical help – imbued her with a stiff, regal posture, and you see this in her demeanour, over and again. In her self-portrait *Me and My Doll* (1937) we see her sitting upright on a rush-based, simple wooden bed on a terracotta-tiled floor. She is dressed in a long green skirt with frothy white flounce that hides her legs and a loose blouse with a band of red embroidery around the neck, and she holds a cigarette – her ubiquitous attendant, counterbalance to the artist's brush. A large, undressed doll (she liked to dress and undress her dolls) with porcelain-white skin – in contrast to her own – sits beside her like a phantom child. But look closer, for the initial impression of tranquillity and innocence is disrupted by the fact it has a damaged foot, in wry acknowledgement of her own.

In the photographs, of which there are many – for Kahlo had a magnetically compelling visage and an ability to look straight through the camera to the viewer's eye – it is evident that she was a gift for photographers, including her father, who documented his favourite daughter throughout her childhood and early adulthood with the careful objectivity of love, and her lover, Nikolas Muray, whose technically magnificent colour carbro portraits made us fall for her too. Here she is in a picture by one of the leading art photographers of the day, Edward Weston, in San Francisco in the early 1930s, newly arrived; on the cusp of becoming herself. She is wearing a fringed shawl

and the weight of her country's history in the form of a triple string of heavy, pre-Hispanic jade beads unearthed from graves: single beads once placed in the mouths of the dead, strung together to encircle her stalk of a neck.

Many years later, our conservator finds touches of green paint on the necklace, as if a brush has been held against it to match their hue; these very beads can be seen in several of the self-portraits and were buried for a second time, in a locked bathroom for half a century after her death, alongside most of her personal possessions, and only discovered a decade or so ago.

Many women photographed Kahlo too, for the development of hand-held Leicas and Kodaks unarguably allowed physical and artistic liberation, as reportage journalism became a profession that was, uniquely, open to women, who were able to traverse diverse political terrains under official protection as news gatherers and image collectors of the artistic milieu of their time. I list them: Tina Modotti, her revolutionary friend and artist; the French-German photojournalist Gisèle Freund; her compatriot and friend, Lola Álvarez Bravo. They sought her at home, mostly; in her bed, in her garden, camera-ready, dressed as if for a carnival, regarding herself in one of the many mirrors that filled her house, offering a kaleidoscopic multiplicity of images that, patched together, in the end, conceal as much as they reveal, for she is always in control. Perhaps her true self can only be seen through the mirror, so important for the self-portraitist; one was even set into the canopy of her sickbed by her parents so she could see, and paint, herself. And all the while that she is standing, sitting, lying, we witness this regal nature that was a combination of physical injury and powerful, charismatic personality and *difference*.

This differentiation between herself and others was epito-
mised by a colourful and dignified way of dressing that eschewed
fashion and convention, down to her black bird-wing eyebrows
and sable-soft moustache, that drew on the regional clothing
and textile traditions of Puebla and Tehuantepec and other
regions but that was – and there is no other word for it – mixed
up with vintage. This took the form of skirts cut from the silk
of nineteenth-century gowns, shawls from the same century,
American thrift-store blouses, jangling jewellery of little or no
value (except for the heavy gold dowry necklaces sourced from
the Isthmus of Tehuantepec). She wore her long skirts with
under-petticoats and flounces (removable, for laundering) that
swept the floor, and stitched bells onto them so that people
could hear her coming; and her embroidered blouses were
loose fitting, in the traditional way, hence without fastenings,
for they were simple lengths of textile seamed at either side
with a hole left for the arms and another for the neck (such
garments can be quickly folded and put away, and take up no
hanger space), and these could be easily pulled on and off, for
someone who had to wear a corset. And these plaster corsets,
with their solid porous surfaces, were like frescoes on which
she could paint, so that she was wearing another layer, body art
if you like, bearing her own brushwork – an act of bravado
to decorate one's tormentor as if, as my curator friend said, she
had *explicitly chosen to wear them*.

The corsets, like the paintings, are an X-ray into her pre-
occupations: communism, in the form of a hammer and sickle;
pain, shown as the torture of a spine depicted as a crumbling
column; childlessness, for one has a delicately painted unborn
child over the abdomen, the image taken from an illustrated
obstetrics manual. She dealt with loss by studying it and by
painting it, and in keeping with her country's close relationship

with death, even kept a foetus in a jar in her bedroom, said to have been given to her by one of her surgeons. The bandages that went to make the corsets, the plaster that bore the imprint of her body, the half-shells that survive (for plaster corsets have to be cut down each side to release their occupants) reveal their internal truth to form – for example the dip to accommodate the breasts, the swelling out above the hips, the sweat. They emulate the way that a couture garment, made for a specific body, with its own internal rigidity made not from plaster but from crin and baleen and other stiffening materials, can be regarded as a body mould, a source of information from which internal dimensions can be taken so that, if needed (and it was needed, once, in the museum), a client could be identified without doubt by their torso, if one had another of their corseted garments with which to compare, and so they bear testament to the uniqueness of each body.

No one is symmetrical. I should know; scoliosis runs in the family. So, when we look inside those plaster corsets and see the faint texture of bandage and imprints of her pores in the plaster, we are also seeing the shadow of one upon whose body it was moulded; who once bore its weight. Casts and moulds, corsets and girdles, sweat and wear; asymmetry, a fragile spine. Whether medical or fashionable, what could be more intimate, especially when it protects the beating heart?

OVERCAST

I'd been in low spirits and found scant pleasure even in things that had delighted me before, like snowdrops, or a new cardigan. Someone said that the best cure for malaise was to look up. I didn't know whether that meant looking on the bright side or looking upwards, or whether they were perhaps the same thing. So I started scanning rooftops and chimneys, the elaborate Victorian brickwork of London streets that only attic dwellers see, and the leaded, curlicue roofs of end-of-terrace houses, oriental domes of builders' fantasies, dates carved in stone, the high porches and porticoes of churches and community halls, and always gutters, gutters edging the roofs, signing off the edges of slopes, to irrigate the clay-clogged gardens of suburbia.

I began to look higher, at treelines skeletal against the sky. I followed gulls as they traced the course of the river that cleaved my city in two, winged incomers from the sea circling and crying improbably over the droning traffic of central London. I watched planes plotting their criss-cross trails, pushing the thin air through labouring engines, propelling themselves to other continents, other skylines, a community of travellers holding court above. And I felt grateful I was not one of them,

that I was safe on the ground, despite the memory of one brief late-night flight that I had resisted, feared and dreaded but that overwhelmed me with its beauty as the plane flew into the setting sun, and the clouds flushed and dilated a celestial pink.

I climbed to the top deck, holding fast to the sticky handrail while the bus picked up speed, and hogged a window seat all the way from Victoria Station to south London. We crossed the Thames, and I looked through the dirty windows, past the rain and sleet, my head at a neck-cricking angle as I observed the doughy sky, hoping for a glint of light to part the clouds. In the park I stood like an eccentric, looking up until I was dizzy, and then puffing, hands on knees, until my head stopped spinning, or at least was spinning at the same speed as the earth as it tumbled on its elliptical orbit. I clung to the fact that gravity would keep me safe, stop me flying off the earth like a fleck of dust cast into the firmament.

I started photographing clouds, preferring the backlit ones, tipping my head, getting them in my sightline, nearly blinded by the unwise habit of keeping my eyes open to the sun. I included a bit of tree, the beak of a lamp post, just to ground myself, keep a sense of perspective. The sky's indifferent grandeur made it impossible to take a bad photograph; there were no duds. My spirits lifted. Each restless cloud formation was unique, as if a maître pâtissier was stirring up the silt, forming pudding clouds, lobbing meringues and wispy curls of icing that slowly dissipated; and how that same pantomime was performed by moonlight too, as the charcoal-smudged clouds stole across the darkling sky.

GOTHIC

A pale grey moth lay on the bed, two wing spots and a tracing like dirty lace its only concession to ornament. As I shook the covers it fluttered and flew unsteadily around my face. Later, I saw a dusting of shadow wings on the white sheet and supposed I must have sat on it, ending its short life.

The intruder light in the garden clicked on, making the plants alien, theatrical, too green. Bewinged bodies bumped and circled in its beam, confusing it for the moon. I ran to close the windows, dreading the stealthy bite of mosquitoes, the brush of wing tip against shoulder tip as I lay, uncertain, in half-sleep.

In the bathroom woodlice hesitated, antennae feeling out the upended, brittle curls of their forebears. Mice skimmed along the skirting board followed by their tails and our dog twitched and groaned in his sleep, his hoary feet running, running in the air as if valiant and young once more.

I dream, face down, entangled in my T-shirt. *Unfuck the world*, it says; I only slept in it when I was alone. I used to wear white nightdresses with lace collars and cuffs as if I was a something out of a Gothic novel. It didn't occur to me that I had been laundering the clothes of the dead.

We travel to Germany and sleep in a room overlooking a cobbled courtyard. Trees blow in the breeze from the mountains and the vineyards shiver in the moonlight. Silver teapots and etched glasses glimmer, a chandelier sways and the duvet lies heavily on my chest.

Our friend sleeps with the door open, to let the bad things out. Her shoes are placed neatly by a chair and her bedside table is empty. She asks for nothing. We cook anyway, laying the table with unaccustomed care. She nods and passes the dish with both hands.

In the morning, I envy the quality of light, the stacked porcelain, the delicate chairs and the wooden shutters that open to the morning air. A mauve rose – *Veilchenblau* (1909) – smothers the front of the house and fills the rooms with the scent of fallen fruit.

A moth rests on my hand. I hold still, looking at its finery, its maroon wings spotted with iridescent blue and its under-petticoats of yellow. We call it *Trauermantel*, the Mourning Cloak moth, says my friend, but don't be afraid. It's not an omen.

Sixteen · IMMERSION

LOST

We were sitting on the beach and I was watching my mother cut out triangles of blue and white gingham. She and my aunt were making bikinis by hand and we had to be patient. We'd never had bikinis before. It's easy, my mother said. She was a confident seamstress.

She put a safety pin through a length of white elastic and let me push it through the waist of the bikini bottoms. This was to hold them up. She sewed the ends together and bit the thread with her teeth. I put them on while she held a towel up so no one could see.

Every day a lady would walk along the beach, her black skirts dragging in the sand. She had gold earrings and sold doughnuts from a basket. The custard inside was sweet and warm. Someone else sold Chupa Chups on plastic sticks for a peseta. We liked those too.

I walked down to the sea but when I turned round the towels and windbreaks and picnic boxes all looked the same and the smell of suntan lotion and the bright sand made me cry. Someone took my hand and we went and sat in a hut.

A man with a wrinkled face and holes in his head instead of ears talked but I didn't know what he was saying. My father and mother appeared at the door and I wasn't lost any more. I wondered what was wrong with him, but they didn't know.

I chose a tiny doll with a green plastic tail where her legs should have been, and it twisted about so you could make her swim. I played mermaids in the bath and her hair began to come off. It was black, and she looked just like the lady on the beach.

WATERMARK

I'm sifting through old photographs after my parents have died. I want to put them in order, to know where I stand. I turn the pages of anonymous babyhood to when I think I start to be me, see glimpses of my ebullience, red-cheeked and tartan-trousered, laughing at the camera – and also of a worried self, a little older, hair cropped and unsmiling. It's as if the pattern of my life – ricocheting between certainty and doubt – was set so early that I know no other way.

I pause at a photograph I've never really looked carefully at before. I'm standing by a lake, close to the water's edge. Tufted ducks linger nearby. Now I see that I have bread in my hand. I turn the image over: *Hyde Park, 2 years old*. The trees have lost their leaves, and there's a misty feel to the air. I am sturdy on my feet, self-contained. My shadow is faint, a penumbra cast by the weakened sun. The Serpentine recedes into the distance, mirroring the colourless sky.

I was born in a council flat in Pimlico. Four flights to lug the shopping up, my mother said. She didn't know whether to take me first or leave me in my pram downstairs. The square had once been genteel, but its white stucco terraces had long been pared into flats and bedsits, and its garden railings melted down for war. It was built on marshland dotted with ponds and rivulets that meandered down to the shoreline. The Thames was so close that the square, in its heyday, had its own jetty.

My family's history is blurred, our source uncertain. My grandfather fought in the Boer War, and my grandmother had long auburn hair and sang in music halls. Theirs was a late marriage, and she sold his medals after he died, when times were hard. She lived close by, in a tower block overlooking the river, built on a bombsite where docklands once thrived. A millionaire's view, she said, as we looked down at the glistening river.

Today, I stand by my pond, watching clouds silver its surface, and see my face, shadowed and remote. Underneath lies another world, clogged with algae and teeming with life. A plane drones overhead. I imagine soaring far above the earth, wingless, defenceless, trusting in the glass portholes to withstand the air. Below, I see rivers and lakes, watercourses and seas like winking mirrors, catching the sun as it wheels across the sky and, as we descend, the sinuous bodies of swimmers as they turn beneath the waves.

I dig a hole for a rose, for my mother, plunging my hands deep into the soil. The earth fills my nails and its surface imprints itself on my knees. My shoes are heavy with mud, and as I wash my hands, a fine brown stream of water circles the sink, tracings of grit around the rim. Night falls. The trees stand rigid, skeletal against the hemisphere, as a slow wash of blue passes over and the low clouds suffuse first pink, then blood-red. I turn the light on and lock the door, waterlogged with memory.

TIDE

It's an early-nineteenth-century pair of breeches that has been in the museum since 1902. We know this because the acquisition number is 16B–1902. They are part of a wedding outfit, I learn from the catalogue entry, and have a story behind them for, according to the man who sold it to the museum, they were worn by a fisherman who later drowned at sea.

The description becomes more detailed. The wedding took place somewhere between Quimperlé and Pont-Aven, in Finistère – *the end of the world* – with its wild headland and rocky outcrops. Inevitably I hear the rhythmic incantation of the shipping forecast – so reassuring to the landlocked, but rather more essential to those tossed around at sea, perhaps battling the waves of the Atlantic where the fisherman, I imagine, lost his life.

I read on: *the tight gathers, which resemble ripples on a sandy beach after the tide has retreated* … This can't be possible, I think, checking I'm on the right website. Curators don't normally succumb to metaphors. But it is the museum, and here's a picture too, a detail showing the gathered linen, which does indeed look like ripples on a sandy beach after the tide has retreated.

The gathers at the top are formed by eight rows of hand-stitching, using stout linen thread, and the stitches at the top are tighter than those below, creating a narrowing at the waist and a swell for the hips, almost sensual in its curves. I want to

know about the rest of the outfit, what we've got to say about that, and widen my search, looking for the missing parts.

Here's the bridegroom's jacket. It's rich and complex, the black felt offset by velvet cuffs trimmed with silver braid, while on the waistcoat waves of rich embroidery, spangles and glass beads lap against the neckline, echoed in the heavily embroidered and fulsome skirts of the fisherman's bride. How rare this double outfit is, with its story of love and death by water, and its unexpected ripples of words.

MEMORY FOAM

He is nearing the end of his life and, when I brush his coat, I can feel his ribcage. His hearing is going – although it's always been selective. He's having trouble with the wooden floor, and I heave him up, setting his back legs down firmly. He trembles with the effort. On walks, he is like a geographer plotting a chart, sniffing out new leads, although he's done the route many times before. Anxious to get home in the dusk, I pull at his collar and he loses his footing. Although normally compliant, he digs his paws in; his work is not yet done.

I notice he sleeps more and more, sprawled on his bed – a grubby square of memory foam – as if it were a life raft. It worries me; he should be up, ready for the day, touching his lead with the end of his nose, just as he used to do; it was the most delicate of hints.

I have not always been nice. Sometimes he got in my way and I shouted. But mostly it was nothing to do with him, just the unease of a windy day or the frustration of housework or unassuaged thirst. I'd feel terrible and hug him round the neck to say sorry. We were on the edge of land, where marshy sea met sky, and he was reluctant to walk on the gravel. I sat in the back of the van with him while he slumbered, writing these words and stroking his ears, sharing the memory foam.

Seventeen · MIST

LUNGS

I was swimming but didn't seem to be getting anywhere. I flailed and splashed, but my legs kept sinking; they were weak and my frog kicks ineffectual. Suddenly, I was being pulled along, hooked by the straps of my swimsuit on the instructor's pole. I laboured out, and lay on my stomach on a bench, practising breaststroke. I could do it perfectly in the air, but not in the heavy water.

Sometimes, I imagined being a diver, twisting and turning from a great height, arms neatly crossed like a corpse. Later, submersion appealed, a world of dimmed noise where I would lie suspended in a viscous sea, muslin dress lapping my body, feet gently paddling. I was thinking of Toni Frissell's photographs of Weeki Wachee Spring in California, entranced by their watery beauty.

It was a rainy day and we went to the aquarium, restless shapes bearing back and forth, seeking a way out of their glassy entrapment. The white jellyfish pulsed, their frilled rims trembling, and we could see the dark blue walls of the kreisel tank through their translucent bodies; it was smooth and rounded to suggest infinity; no sharp corners to snag their fragile membranes.

Behind, lay the works. Filtration systems, air vents, pumps, drains and sluices hummed, swirling the water around, cleaning it of any particulates, while vats full of microbial foods

brewed, all to keep the trembling, impossible souls of the jelly-fish alive. Ninety-nine per cent water they are, said the aquarium curator. I wondered if they knew things weren't quite right as they bobbed around, and pitied them for it.

<p style="text-align:center">* * * *</p>

I want to do an exhibition, but scupper myself. Afraid of having no purpose, I offer two ideas. One is apt, but I don't want to do it; the other is about water, but I'm unable to say why. Although I know how. I'd flood the vitrines of the museum, illuminate them with flickering sunlight, submerge the muslins and the silks and watch them circle, their lacy cuffs and collars slowly pulsing in time.

But I've been pre-empted. Suddenly, everyone's talking about water; feature films about oceanly love, fashion shoots with sly bubbles emerging from models' nostrils, exhibitions about ocean liners, and shimmering AV projections of waves. Meanwhile, in a pub, I inhale my drink, feel the iced tonic water with its carbonised sweetness invade my lungs, and simply cannot breathe.

I sit on someone's doorstep, coughing and gasping, shocked that I might have caused my own demise from an ill-drawn breath, from trying to laugh and talk and drink all at the same time. For days, my chest aches, and I fear a pip has got stuck in my lungs, tearing its fragile casings. I imagine myself lying on a clean white sheet, being gutted like a fish.

THE WATCHER

In the days of the watchers, all the local people wore back-stays on their feet to enable them to walk across the shingle, read the object label. I'd heard of slap soles (women's shoes with elongated toes that made a slapping noise when worn, mainly indoors) and slipshod (implying some form of disarray, not necessarily in the shoe region) but never of back-stays. But here was a pair in the case at the bird reserve. They were simple, flat pieces of wood, rounded at the corners and secured with a single leather strap that went over the toe of the shoe. It was an art to keep them on, and the slapping sound could be heard from afar, over the marshland and down to the sea. I was intrigued by their particularity.

The watchers were guardians of nesting birds and catchers of egg thieves, the first appointed in 1903 to protect the Kentish plover. Watching involved much walking on shingle which, without back-stays, would weary the calves and rub leather shoes into ruin. I imagine the watcher sitting on the beach, legs outstretched, back-stays on and huddled against the cold. He has a checklist in his hand and is surveying sea birds. It seems an impossible task, given their incessant motion, their dipping and diving, their wave-winging, but there are methods and regulations for such countings.

* * * *

My mind drifts to *stays*, the historical term for a girdle. It's in the plural because they originally came in pairs which were laced together and suggest a stilling, a holding together of things, in this case the shaping of flesh, the moulding of the body. Create a flawless foundation under dresses and skirts, said the Marks & Spencer ad, enthused by the wonders of technology by which we can be re-formed. But before the age of synthetic underpinnings, girdles and corsets used to be ribbed with thin strips of whalebone harvested from the jaws of baleen whales. The baleen flexed and softened with the warmth of the body, moulding the form to the torso, for these strips were not really bones at all but a keratinous grating through which the whales sieved seawater to capture krill. Who knew so many had to be lost to fashion?

At the bird reserve no one minds if you have bulges or expects you to be held together. People open doors for each other, murmur their thanks, cast sympathetic glances. There's a purposeful toing and froing to the toilets, the scrape of walking boots on gravel, and in the shop the volunteers get muddled with the till but we're in no hurry. I order a self-service coffee: espresso, regular or decaffeinated, they say; it's the same price but we just need to know for stocktaking.

I learn a lot from the small display, hadn't expected to find anything so curatorial. I look again at the back-stays. The sea-darkened wood and aged leather seem Japanese in their economy, have a functional kind of beauty. A long, thin clipping from a newspaper is displayed awkwardly and I bend down to read it. It's an obituary of a watcher, a Dungeness fisherman. *His life work will endure; for he has trained good men to follow him*, it says. Jack Tart was his name, as brief as brief could be.

In the pub that evening plates of fish and chips and mushy peas pass overhead on their way to hungry families sitting in

the conservatory, condensation on the windows blurring the lights of the fishing boats out at sea. We are having a weary conversation about life and health and work and availability, but that's not really what it's about. I want to say: we need to keep a watch on the years. *We haven't got forever*.

There's a TV monitor on the wall, and it's showing the location of ships in the English Channel. Every few minutes they realign, like chess pieces, as the satellite sends new information about their progress. The red markers are tankers and the blue ones are cargo vessels. Near the coast there are clusters of yellow; these are the fishing boats and each has its name hovering above: *Our Cathlene, Kingfisher, Donna Dee*. No boat goes nameless.

We walk the shingle with its eyeless architects' houses, and its fishing huts and ancient iron boilers once used to season nets to guard them against the salting of the sea. I think of the sound of the watcher's back-stays carried on the cold wind and the birds crying out as he raised his nets and of how Matthew Arnold compared the sparkling waves to *the folds of a bright girdle*, as if the sea's embrace was holding the land together. He, too, was a watcher and knew his seabirds well.

HARBOUR

I journeyed for a day just to avoid a train that had sliding instead of slam doors. I couldn't justify it, for I was unproductive in my travels, unable to use the hours other than regretfully observe them pass, like empty cars on a carousel. You could have flown to New York in that time, he said. I could, but that would have been problem enough, I thought, catching a glimpse of the late-afternoon sky in the wing mirror. These skies were the gift at the end of the journey. Framed by the window in the flat-gabled B&B – without the view it would perhaps be unacceptable, although we liked its ramshackle ways – they performed their slow successions in an exquisite dalliance between light, vapour and seaborne winds.

As night fell, I climbed into the brass bed and sank into a daydream just short of sleep, recalling another journey to a watery city where I had lodged in the attic of a canal house one flight of narrow stairs up and one room wide, with a troublesome stove that the melancholy violinist on the floor below had to light for me and where I had no bathroom (washing at the sink is not such a privation) and where I cycled to college on a stolen bike and felt something like happiness unfurl. Aloneness detached itself from loneliness as if the twinning had been a misunderstanding.

I didn't have the strength to push the heavy duvet away, nor could I shift the melancholy of knowing that probably I shouldn't have come, that he needed time alone. But in the end, the rain and the sea mist softened the air, and the weekend was not really problematic. I liked hearing the scratch of pen on paper, and the rinsing of brush in water, but then I was off. As the cars gushed past, I thought of how slow we all used to be, and how protracted journeys were an accepted fact of life, and how the road I was walking used to outline the coast. Its curves were now just echoes of those lost headlands, for silting and the displacement of sands and shingle by tidal surges and floods had created impassable saltmarsh between ancient route and retreated sea, and stranded the churches of the prosperous ports so that they had become moored on their own grassy islands.

The following night, flood warnings filled my dreams (carry everything precious and irreplaceable upstairs, they said) but in the morning, the road and marsh glistened and the gulls upped and fell, and in the distance white breakers heaved. I thought of the meadow before the church that bore the faint outline of the once bustling harbour, where ships from the Low Countries had unloaded their goods (in medieval times it only took a day to sail to Amsterdam, but four days to make the journey to London), and I thought of those Dutch sailors who were buried in the graveyard, and how they were no longer sea-side, and how distance is just a state of mind.

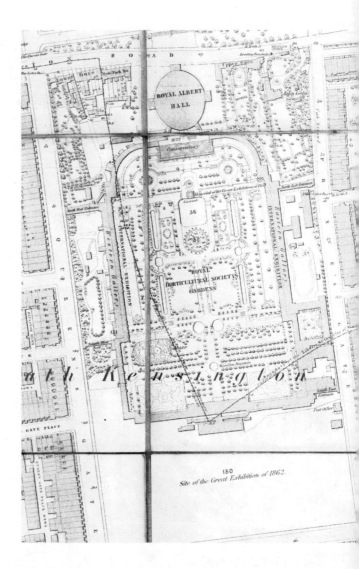

Eighteen · ARCHIVE

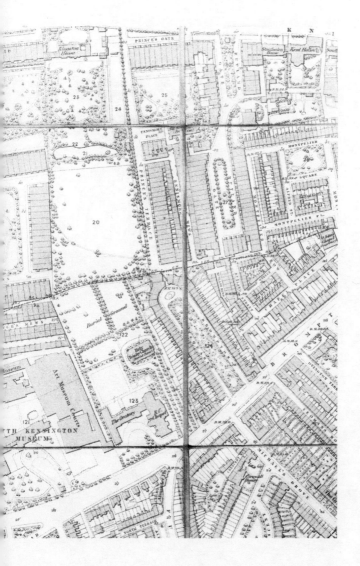

INVESTMENT

It's cold and raining. I get out of the car and run across the courtyard and up the steps to sign in and get my keys. We won't be here for much longer. They'll probably retain the wrought-iron staircases, with their mahogany rails polished by the hands of those who don't like lifts, when the building is turned into flats. Once, the archives were open-plan offices on a vast scale, filled with rows of desks and diligent clerks at their adding machines and ready reckoners, working out compound interest for the Post Office Savings Bank, formed in 1861 for those who had never had anything to bank before (my mother would be one of them).

A huge overcoat made of drab – a densely woven undyed wool, from the Old French *drap*, for cloth – with a shoulder cape meant to shuck off rain at a time when it was thought unmanly to travel inside a carriage, makes me think of the horses and mud and unpaved roads and the danger of chills that journeys must once have entailed. How important that the weave of the wool be tight, and the lanolin not washed out, and the padded lining warm, and the leather boots and hat, that were also essential to withstand the vagaries of the weather, properly tanned, the better to defend former travellers from the weather.

The physical weight of the archive – for cloth is heavy – and the metal cupboards that shield it is immense but puts no strain on the foundations of the building: it is monumental,

weather- and shockproof; built to last. The glazed bricks that line the corridors and walls were progressive for the age; hygienic, protective, like the waxed cottons and rubberised canvas and polyvinyl chloride macs of more recent times, assiduously reflected in our holdings. The building was once a repository for people's savings – for schooling and investment and health and hope and old age – and those figures had to be added up, reconciled, recorded, just as we collate our records, update locations, refold and rehang and rearrange. The clothes that have survived the storms of time don't need to withstand the weather any more. We've banked them in perpetuity.

ELYSIUM

The repository was shadowy, silent, and littered with ephebes and warriors, nymphs and satyrs, herded into bays. The figures were assembled from a brittle kit of parts, held together with rusting pins to conjure up the gods and to provide an education in the antique for those who cared to collect and those who cared to study. Many were in a state of incompleteness, as if there had been a distant battle. Some had pale arms laid carefully at their feet, while their noble heads, shelved on metal racking, looked on; many were chipped and stained; one was labelled Chatsworth Apollo. I didn't know where its body was.

The statuary and the moulds from which they were taken were made of plaster, cast in the nineteenth century from originals chiselled in marble and stone, survivors of war and of ruin. The museum specialised in the art of the cast, sending plaster-craftsmen to capture and reproduce the delicate tracings of hair and hands and profiles and torsos and legs of muscularity. Everyone could have a taste of Rome, admire them in the galleries, measure them up in life drawing classes, know, by sight, what it meant to be antique, infuse their aesthetic sensibility with proportion; grace.

We were about to leave, awed and overwhelmed by our pallid host, when we saw a single, besandalled foot high up on a shelf. The tracery of veins and the sensitive toes were so finely rendered that I could imagine the figure it was once part of

about to take off, to run with freedom. We placed it carefully on the table, diligently photographed it. Strangely, we saw the same foot again, just a few weeks later, in another temple to taste and art. The point about casts is that they can be retaken, as long as the mould is sound, and the spirit willing.

A cast of my outstretched hand sits on the mantelpiece, taken half a century ago. I'd gone to sculpture classes at an artist's studio in Kensington – drawn, even then, to art's making. Here, I learnt how to mix plaster, stirring it into a bucket of water until it went creamy and then quickly spreading it over the lumpy figures we formed in clay before it set. We decided to cast my hand, and as the plaster began to heat and contract I felt entrapped. The release was exquisite as I picked the dry plaster from the hairs on my arm. We filled the voids with ciment fondu before sealing them together again, waiting until we could chip the mould away and my hand's double emerge, grey and hard and streaked, but intact. There it is, with its hand-tracery, lifelines, knuckles, nail crescents, all fingerprinted with my essence.

CONFINED

The storeroom was bitingly cold, unreasonably so given it was spring-like outside. The trouble was, the windows were shut fast and no sunlight was allowed in because it would fade the textiles. The thick blinds also muffled any external sounds, making the air deathly silent, oppressive to the spirits, and bathing the area in a dim, yellowish lux. It meant we couldn't see properly and were making decisions based on touch, guesswork, keen to move on and get out, to subsume ourselves into the sounds of the street and the warm, dirty air exuding from the underparts of passing cars. The chill stayed in our shoulders all day, and the sense that we had rushed, skimped, skimmed; it meant only one thing, that we had to go back, start again.

I felt disheartened with the garments, with their weight and intransigence, and reluctance to divulge their secrets. The impermeable Tyvek coverings felt slick under my fingertips, the zips snagged and the padded hangers kept catching at my sleeves with their hooks. I missed the old store with its sweet, cankerous smell of age and sweat and camphor, and the proximity of the garments to our offices – just a quick step away. The storage was inadequate, and the priceless garments were crammed too closely together – that I admitted – as I tried to interleave them with tissue, so that spangles and gilt lace could not entangle, cause damage where it should not. I knew we had

to decamp, but the separation of curator and collection felt like a permanent loss echo throughout our days.

But things took a turn, for the storeroom spirits urged us to linger, unwind the threads of time a little longer. We stumbled across a court suit that had survived four centuries, its doublet and breeches so repaired and so brittle they could crumble under the lightest touch, and the only intimation of their original, glorious colour found in the nooks and crevices of fabric where the destructive light had not gained ingress. The suit had been relocated to a cell all of its own, one of a row of converted gents' toilets in a building so vast one would have thought there was room aplenty. But in fact, the cubicle, locked on the outside not the inside now, was perfect. With no crowding of rails or anything much happening at all, it was a safe, if impertinent, last resting place. Here lay costume's history, robed in indignity, impossible to mend, impossible to display, impossible to throw away.

Nineteen · HOME

DRIP-DRY

While everyone was away, the temperature dropped as a cold wind from Russia swept over the country and sent us shivering to our beds. The water in the pipes froze and, as its quivering molecules rearranged themselves, became crystalline. A weak spot (possibly a join or poor weld) was breached on the top floor, and when the temperature climbed, and the ice reverted to fluidity, the water took delight in coursing through the fracture. And because the pipes were embedded in the walls of a house that had not always been a house but had once been part of a piano factory, the water found hidden cavities in the structure, and thereby a series of downward routes, aided by gravity, into every floor, and every room.

The destruction was so complete that the situation was only recoverable by emptying the house entirely and stripping the walls back to their original timber and brick. And during this reversal of time, this undoing of the labour and love that go into making a home, the original layout was revealed showing that, although it had looked like a normal – if warmly welcoming – abode, with its books and Persian rugs and Venetian blinds that threw chords of light onto the wooden floors – it perhaps had never been quite fit for purpose, hiding a terrible vulnerability that only needed a half-term break, a freeze, a thaw, to start. It was a calamitous chain of events that required a year to remedy for, once the damp had got in and the relative

humidity in the house rose, it couldn't be stopped. The keys of the grand piano tilted, the sheet music wrinkled. Beloved books cracked when they were opened, releasing a whiff of mould and a scattering of black fox marks around the edges caused by the rusting of the iron contaminants within the paper. The wooden floorboards that had risen up in protest were destined for the skip. The mahogany chest would not release its drawers, and inside those drawers the clothes were infused with a smell of verdigris that couldn't be washed out, and the shoes and coats that had been in the hall were speckled with green, necessitating a new wardrobe, in both senses. There was nothing to be done but decamp: find a foster home which would be warm and dry; hold their loss safe.

* * * *

If my father was ever going to lose his cool it would be from rain and running taps, and from liquids generally being where they shouldn't. I once saw him on the roof in a storm, fixing tiles, with my mother wringing her hands as if squeezing water from wet clothes and him shouting he was all right. Later, I let someone stay in my flat and they left the shower head trickling on the floor and it seeped down and made the plaster in my father's shop below so sodden it had no strength left to hang on, and gravity pulled it down in great damp clods, and that was a bad day. During a time of great crisis, he would become so apprehensive about leaks that he had to be admitted to the care of others. His anxiety centred around the incompetence of plumbers, and because he had a certificate in plumbing, which he was quite proud of, he did know the consequences of a faultily welded pipe and the catastrophe inherent in such carelessness.

He was right to be afraid of water, because it could nearly lose you your home, and all that was within it, and his home was his security against poverty and terror and lawlessness. But homes have a habit of staying with us, even when they are drenched and half-destroyed and, in my mind's eye, the flooded house hasn't gone, or rather it will be back, just the same as before – perhaps even a little renewed and a little improved – and I will again hear distant piano chords, for even without our things, and the walls that square up on our behalf against the world, we carry our asylum about us, feel its benevolence and its burden of care.

INTACT

(For Richard Meier)

Although the tea bowl is very old, it is unblemished, for it has spent two centuries resting on the seabed. It sits unanchored in its saucer and slides a little when I pick it up. The outside of the bowl and the underside of the not-quite-matching saucer are a rich brown, all the better to set off the watery underglaze with its pattern of bamboo and peonies that must have been reproduced a million times. Still, mine feels unique. I hold it in the palm of my hand, run my fingers round the curve of its lip and foot ring, and feel its delicate permanence.

I imagine the Dutch merchant ship burdened with cargo: tea, gold ingots, raw silk and the 150,000 pieces of porcelain – high-quality ballast made specially for export, to be auctioned on arrival at the dock and destined for the tables of the middle classes who were crazy about blue and white, and crazy about tea. But this didn't happen, for in January 1752 the *Geldermalsen* hit a reef off the coast of Indonesia and the dinner services and garnitures and vases and tea bowls sank down to the bottom of the South China Sea.

I think of the bales of silk slowly disintegrating, stroked back and forth by the currents until the tattered fronds drift and disperse, but the porcelain holding fast, bedded by 687,000

pounds of swollen tea leaves, and the stacked bowls fused together with coral and crustaceans, and my modest teacup and saucer waiting to be dredged from the silt by marine geographers and treasure hunters, washed in seawater and then me scraping together all the money I had, just to have a piece of the story.

I consider the persistence of clay, and how the loss of the tea and the fine silks and the gold was much more significant than the kilns of porcelain, for tea was so costly it was locked in mahogany boxes lined with silver foil to keep it fresh and sipped from tiny bowls like this. I unwrap the tea bowl from its bed of tissue, put my lips to the rim, perhaps the first person ever to do so, and shudder at the impossibility of use. Yet, as my poet friend says, what life for such things *without that one life-giving thing – the possibility of breaking?*

THE MUSEUM

There was always a museum in our house. The glass-fronted cupboard in which the objects were kept was shallow and the sides rough, as if it had once been built into a recess of the type it stands in now, beside the chimneybreast. I first saw it in a junk shop and thought it far too fine not to come home with me and provide a place for my ephemera.

There was talk of it being from a church, perhaps because of the Gothic arch of the mahogany frame and the watery glass and the musty smell inside. I could imagine it holding chalices, communion wafers, alms bags, flagons, cruets – the type of objects provided by church furnishers with Dickensian names and a trade in the trappings of belief.

Our trappings were modest, an accrual based on sentiment and scale. If I liked it, or if it was too small to know what to do with, it would go in the cupboard, and over the years the shelves became congested with bits of china, baby teeth in jam jars, postcards, keys to lost locks, a dented silver purse, a crimson velvet frame, a mermaid with black hair.

When we packed everything away, because builders were coming in and we were being careful, we labelled the boxes by shelf number, as if it really was an archive. But it's a closed collection now, there will be no more Objects Submitted on Approval for Gift; no more slippers made from cardboard or

school certificates curling at the edges, or unsteady pinch pots, or faded silk roses.

I de-accession, place the glass-head pins in my sewing box, the embroidered handkerchief in a drawer, the lead soldiers in a tin. I keep the tiny notes in tiny envelopes written by tiny hands and the red leather shoes and the matchbox full of secrets close, lest they go astray as small things sometimes do. It's just a cupboard now. It was only a museum because we said it was so.

SLIPPAGE

Fabric is so compliant; all it takes is a needle and thread to give it some purpose. There are pros and cons to this flexibility. Its survival is threatened not by being dropped on the floor, as the porcelain teacup I'm holding would be, but by wear and tear: the effects of light; moths; stains; damp; rubs and abrasions; cutting. I think of the havoc my scissors could cause as I chop away at my frayed jeans and throw the fragments into the bin. I won't trip over now, I think, pleased to have got away with not having to stitch them up properly, but before I know it, I'm airborne. I've laid a rag rug on the polished floorboards, not thinking about underlay or non-slip carpet tape, and it's nearly my undoing. The texture beneath my feet comes from a melange of discarded garments turned into strips like the fabric shards from my jeans, the offcuts, scraps and shreds roughly woven together. I don't know where they've come from, for although the label says *Made in India*, the bales could have travelled halfway across the world and back, perhaps even with one of my own thoughtlessly discarded garments in there. I pick myself up, look at the empty cup that I still seem to be holding, and realise that my tea has arced across the room and, in its own parabolic journey, soaked everything in sight.

Twenty · VERTIGO

THE CLOTHES MOTH

Tineola bisselliella (Hummel, 1823) fluttered perilously close, not realising I was about to instinctively clap it between my hands, making everyone in the room jump. Within half a breath, it became a brown smudge that I dusted away without regret, even though it could cause no damage for it does not eat.

The webbing clothes moths are a sign it's too late; the larvae have hatched, and the pheromone traps (exceedingly sticky cards that attract the male by replicating the smell of the female, chemically) are furry with bodies. Now I would have to search through my wardrobe weighing up the collateral. It was full of iterations of my uncertain style, offering numerous opportunities for a moth to lay eggs in the dark crevices, creases and folds of the garments; the criminal evidence: little white coils spun by the pupae which are especially keen on cashmere jumpers and wool coats and jackets, the inside of cuffs and the underparts of collars. And although I can freeze the besieged-by-moth cloths (−18°C, for two weeks) I can't repair the holes; it would only make them worse because, in a way, they are quite delicately done, nibbled in imperfect circles that perhaps should simply be accepted, and could be if one lived in a country house and had more important things to think about, like gun dogs and family silver and ancestry. But I don't, so the situation must be tackled. Infestations require discipline and a commitment to housework, because the cycle is remorseless.

The advice is to start by emptying wardrobes, shaking the clothes out (moths hate being disturbed) and hoovering, for they can even live on dust. But I get distracted, start sorting into summer and winter piles, as if I was a socialite planning for the season. This is entirely fruitless and I give in to a resigned fury about the impossibility of freeze-framing fashion so I can have a proper think about it, and don't even bother to chase my moth guests as they fly weakly around the room.

The Romans left a trail of winged smudges all over Europe too, also driven mad by the ruinous consequences to their trunks of hand-spun wools, commissioned for colder climes as they traversed the Pyrenees, and their grain stores (clothes moths like a varied diet), essential for the winter-anxious months. Despite their indefatigable desire for conquest, the legions of the empire were outlived by this frail but most persistent of enemies, whose reproductive capacities and Latin name seem designed purely to annoy.

DUST

The living area was smaller than we'd expected, and the grey sofas that we collapsed into when we arrived were small and hard, as if the house didn't welcome us. There wasn't enough crockery and we were constantly washing up cups and bowls and glasses because the tiny dishwasher that was kept under the stairs was awkward and inefficient. It wasn't that the place was cheap, far from it, but perhaps it catered for people who ate out.

The girls called from upstairs, frightened. There'd been a tapping on the bedroom shutters and, when they opened them, a large raven flew off. I said someone had probably fed it in the past, although didn't believe it and couldn't but shiver at the thought of Poe's 'Nevermore'. Despite this, we slept deeply, for the beds were wide and comfortable and the white sheets smooth. It was where we could forget.

We tried to keep ourselves occupied but had trouble getting up in the mornings. We drove to a market in a nearby village but got the wrong day; we tried another but arrived just as it was closing. In a monastery near Joucas, I photographed his shadow in the half-shade and silence of the cloisters. Somehow, his fragility seemed exposed by the not-quite-warm-enough sun (it was a cool September, they said, quite unusual) and our sudden chills at dusk.

The holiday house came with a small, round pool that you had to get into by climbing a shaky ladder. Insects floated on the

surface and I worried that the water hadn't been chlorinated. The rough lawn was dotted with scrappy trees and in one a nest of hornets hummed and troubled. After that we kept away from the garden, went out for day trips and found a bar where we could look over the valley, find some temporary peace.

I studied the guidebooks and we drove to a hilltop village, where the houses clustered together, washed in shades of russet, as if bathed in a perpetual sunset. Ochre had been mined there for millennia The quarry walls and strange pillars formed by wind and rain were marbled with reds and browns and yellows, like a 1970s fabric. *It is not advisable to wear white clothes*, we learnt too late, as the billowing clouds dusted our legs.

In the tiny museum with its phials and faded labels and stories of how the hills had shared their iron-rich tints, we thought of the cave paintings we'd seen years before, a mile inside the earth, and the guide plunging us into blackness, before flickering a torch under the antelopes and bison so they looked like they were running; and all around there were ochre handprints, left by those who had brought darkness alight.

SAFETY CURTAIN

The church is all that's left of the once populous monastery. It stands high on a hill overlooking the valley, sighted from all sides. A crumble of houses lies in its shadow and in the distance granite peaks salt the hemisphere. What labour it must have been to flatten the summit, quarry the stone, lay the floors, haul the gilded retablos up the mountainside – with their stories of valour and saviour, wild beasts and visitations, and their gold leaf flickering in the sun. There is one populated by figures wearing doublets and harlequin tights and pointed shoes; so lively I smile. Nearby, the jewel: a wooden statue of a pink-cheeked Virgin and plump-limbed child, which was found buried under the altar, saved from theft and ravages and the fire that burnt a thousand books that had educated princes. There it lay, for 700 years, and now it stands, two handspans high, uncased, gleaming with polychrome colour and gold as if painted yesterday. At its foot, a wreath of plastic flowers has been carefully placed, marking out its importance.

We think we've interrupted a service and speak in whispers, for it's a Sunday, and we can hear plainsong, but it's just a recording. The sound permeates the bricks and the recesses and the great domed roof, and the simplicity of the chant is echoed in the church's restraint; this is a valley that does not embellish its architecture lightly. We go up the winding stairs, rebuilt

and refurbished and complete with safety rail, for which I am grateful, and then walk into a balconied room and I understand, for the first time, how the doming of space goes with religiosity, as if emulating the curvature of the earth with stone is a reminder, for those who look upwards, of their own infinity.

Three monumental volumes lie in a dusty case, surely too heavy for one person to lift, although monks were perhaps stronger than I imagine. The covers are brown and worn, shredding strips of leather to reveal their vellum. I don't know what's inside, there are no labels, for this is not a museum. On the further side, in front of a window paned with the thinnest marble so that its veins are backlit by the sun, is a volume of psalms. The notations are marked in black and red, and the calligraphy is on such a scale and rendered so clearly that it was surely meant for a choir, so that all could see and share their song.

Once, halfway across a gantry at the Palais Garnier, high above the stage where singers in jeans and T-shirts were in rehearsal, chorusing out to the empty auditorium and backdrops of skies and temples and ruin-stacked time, I made the mistake of looking down and fell to my knees not in admiration of the songsmiths or the trompe l'oeil safety curtain with its painted swags and tassels, but because such dizziness seemed an appropriate reaction to the untethered space between chandeliered and gilded dome and the armchaired pews of crimson velvet that radiated and tiered upwards to the gods.

MARGIN

They arrived in ones and twos, exhausted, awkward in their gait as if out of place on firm terrain, their stiff-soled shoes clacking on the floor as they queued and clustered around the tea counter. Their faces were pulled back in tight smiles and their voices were high with elation and their ages were hard to determine, for they seemed neither young nor old, and although varying in height, were all of a kind: wiry, short-haired, torsos encased in skin-tight jerseys; arms and legs reduced to sinew and muscle like an écorché model. Without exception, they were dressed for the occasion: streamlined to maximise speed, the fabric and forms tested in wind tunnels; micro-deniered, weightless, temperature-sensitive, bacteria-suppressed, each pair of padded shorts with smooth codpiece and seamless chamois designed to reduce friction; avert road shock.

Ancient racing bikes hung on the walls, heavy with achievement, their leather seats oiled and dark from a time when jerseys and shorts were made of knitted wool for warmth and wick, like the rare 1890s frogged cycling suit we have in the museum's collection that doesn't know where it is stylistically. Blanched cuttings showed triumphs, disasters, old cars and waving crowds at the touchline, perilously near the road's edge, just as they lined the route today, and all the while the hunched-down riders' clanship is declaimed by graphics and logos, marking them out as committed, invested.

As we began our journey down to the valley we passed more riders climbing up, wobbling with the effort, hand welded to handlebar, wheel clinging to road like a cog to a chain, and I was amused by the bright kit and the fluorescent shoe covers until I realised that they were not just for flash, but that non-linear movement draws the attention of drivers; keeps them in the mind's eye. I wondered out loud why they do it. My driver's answer was aslant; he spoke of the effort to ascend and the perilous speed of the descent, and how he'd once seen a rider go over the edge, and how risk was both inessential and elemental.

But by then I was quiet, done with musing, for talk of hurtling over edges had seen me holding onto my seat, as we too descended at what felt like precipitous speed in our hire car, with its anxious, computerised missives, for the sheer drop that seemed inches away on my side caused me to imagine us also hurtling over the edge, spinning, glinting in the air and bouncing on the rocks, over and over, spraying silver shards of metal so far down the crevasse that the sound was silenced, as if it was something that happened long ago. And I thought of how I too am primed with an alarm system all too ready for action and all too rarely needed. But there was no real danger; the tyres gripped the road, the steering wheel responded to the minuscule movements of carpal bone and tendon in all their tapestried complexity and no boulders fell (I had clocked the possibility). The gap between precipice and car could have been a metre or ten – what difference would it have made? It was just the proximity, I say, scrambling for dignity. My driver is troubled by my alarms, doesn't mark time that way. I hang on, looking for equilibrium, still thinking about speed suits and padding for extremities. Perhaps I need to get nearer the edge, risk that soundless fall.

Twenty One · NOCTURNE

RED GLOVES

The quayside is deserted, and boats lean untidily against the floodwall. Across the road the hotel is lit up for Christmas. I stayed there once, after a long taxi ride past dark fields and looming churches and through ever-narrower lanes, downwards towards the sea. I had vertigo and dared not turn my head lest the world start spinning. In the night the humming of a generator filled my dreams.

Through the picture windows I can see retired couples having dinner, their faces rosy in the lamplight. Black-clad waiters lean in like priests, taking their orders, and the white tablecloths are laid with silverware and glass, carafes of wine and baskets of bread. I walk slowly, my torch throwing a circle of light that I step towards but never reach. Far out on the marsh I hear the cry of a curlew, late home to roost.

I'm on my way to the Spar. The fluorescent lights are dazzling as I come in from the dark and I wander around the aisles, unwilling to leave, until someone asks if they can help. I buy some kindling because the stove won't light and some one-size-fits-all gloves because my hands are so cold they ache. The synthetic fibres stretch and catch at my sore knuckles; imbue little warmth or comfort.

The next day, I walk past the stiff line of memorial benches that look out over the harbour – *dearest memories flow with each and every tide* – and along the coast path, the wind pinching

my cheeks. It's low tide and the sky is grey-white and a dog zigzags across the black mud and its owner calls, and the red of my gloves is like a gash in the landscape, so bright it hurts my eyes.

WEEDS

The lawnmower was clogged with compacted grass, and the tools rusted where they lay. The greenhouse was unfruitful, a crystal palace for weedkiller and seed packets chewed by mice. I'd come to gardening late, seduced not by carpets of turf or the pleasures of pruning, but by a need to clear my head.

I was preoccupied with weeds: in particular catchweed, grip grass, Robin-run-the-hedge, country names for the same common nuisance. They irritated my bare hands and clung to my clothes but offered little resistance when I pulled them up, for their great skirts of green were barely rooted in the earth.

Brambles fought it out in what were once flowerbeds, impaling me with their thorns and intimidating me with their energy. I was half mollified when they produced fat black-berries, snatching them before the birds could, and then massacring the very branches that bore the ovarian fruit.

Don't let the docks run to seed, I was told, but they did, scattering hard brown grains everywhere. I tried heaving on their slippery stems. Sometimes the taproots would let go, top-pling me over onto the wet earth. I liked throwing them on the garden path to die.

I picked dandelion flowers before they could metamorphose into clocks and their silken parachutes drift and settle. They left yellow stains on my fingers. I thought of my mother crawling

over the lawn in her white shorts, digging up their roots with a vegetable knife, lost in concentration.

I tolerated bindweed, with its tendrils and papery trumpets, even though it was a silent strangler. Woody nightshade chilled me because of its purple florets and dangerous boiled-sweet berries. Its benevolent cousin, solanum, I let rampage, spreading fistfuls of lax white blooms.

We dragged ourselves out of London. I sat in the passenger seat, laptop warming my knees. People little older than we trudged past carrying binoculars and flasks and shooting sticks. Sparrows flurried and preened in the nettled bank between the car park and the corduroy-ridged field.

An oak tree leant into the bank, roots ditch-wise and limbs crossed, and I saw the sky through its veil of leaves dispersed into a thousand pearly fragments. I was thinking I might write, thinking I might write. But I needed to tidy things up first, clear the ground, get the lie of the land.

THE COMMITTEE OF
REARRANGEMENT

I know these mosaic floors well, the geometry of squares
and other squares, dot-dashes of grey and white and black, the
modest patterning of the walkways flourishing into elabor-
ation, demarking the thresholds of galleries with griffins and
acanthus leaves, the symmetry steering us through wars and
storms and new regimes and rearrangements; the brushing
of wide skirts, of the type now displayed in glass vitrines, the
sound of high heels clicking like metronomes; the creak of
leather and the orderly tread of warders on the beat.

I know that women convicts made some of the floor mosaics
(the museum loves that story) and I know the places where
the tesserae, fused from glass and sand to resemble marble,
have gone missing, gouged out for a cable, pipe or metal strut,
and the patches where things have been fixed with new tiles
that don't quite match. I know what the sticky residue of tar
glue looked like as the black linoleum, put down in the 1960s,
was levered up, with some effort, to reveal the ashy patchwork
like bare skin covered in sticking plaster for too long.

I think of the roofs high above, with their iron walkways
and twisting stairwells and pockmarked handrails that catch
at the skin, and the cast-iron gutters, and Victorian drains,
and porous age, and the London rain seeking the quickest
descent, pulled by gravity, coursing sideways and downwards

and seeping and travelling and insinuating itself into the plaster, and that plaster blowing and crumbling and beginning to fail, and how those corridors and galleries of the museum were once, in hard times, punctuated with buckets to catch the drips, and furniture raised on pallets, lest its feet dampen and rot.

And before that, the building shuddering with the sound of artillery shells and sirens, and shrapnel pitting the stone walls and impaling the red telephone box that still stands outside like a sentinel; and galleries being bricked in because the altarpieces were too big to move; and curators watching as their assets were carried away by horse and cart to be stacked on the platforms of Aldwych Station, or hauled off in army trucks to faraway Welsh mines, until the war was done, and the dust and debris could be swept away.

I think of how men were dispatched onto the roof to dismantle bombs, solder the lead, black-paint out the glass skylights, and how many of them were conscientious objectors, like my father, and how he was caught sunbathing on the sloping gables, the sun's invisible vitamins dancing on his skin, and him being ill with tuberculosis but not knowing it, and how he was young and gaunt and under a strain; the struggle to become middle class, to have books and classical music and art and museums.

* * * *

The building is full of communications. *Exhibition continues here. Exit to South Kensington Underground. Display in process of rearrangement. Temporarily removed.* And we have much to say about the objects too. Some labels are terse, as if there should be no debate. Many more are fulsome, offering great swathes

of words, knowledge sewn together, a piecing together of facts and evidence and opinion and personal, curatorial obsession.

But these aren't the only kind of missives. What I am thinking about too is the embedded messages. The VR on the Victorian tiles in the old bathrooms, with their brass taps and cisterns worked with chains; portraits of artists (all male) rendered long ago by the mosaicists; the nourishing words on the walls of the public restaurant which once offered a third-class menu for the workers: *There is nothing better for a man than that he should eat and drink, and make his soul enjoy the good of his labour.*

I stop on a landing, so suddenly that I nearly fall over. There's a word on the floor where there should not be one, lettered in tiny mosaic fragments. It spells RUST and must have been there for a hundred years or more. I puzzle over it. What does it mean – is it a name, an inscription for some now long-lost architectural detail; are there other such words buried in the building? It's half-hidden away yet deliberate, and I like its brevity. I have never noticed it before.

John Ruskin admired the strange beauty of rust. In an 1858 lecture 'The Nature of Iron, in Nature, Art and Policy', he described how the marble springs of Tunbridge Wells, where the talk was given, were tinged with a *saffron stain*, and the way iron's brittle strength is undone by absorbing oxygen, and how eventually its surfaces disintegrate into *dust*, and how earth and life and blood need its ruddy oxide. The coincidence set me thinking about how the museum's arteries have been marked with the seeping of iron-stained rain and the fact that I've been here for so long and only just remembered the importance of iron, and how it was the armature of the age and still holds fast its core and how it speaks of strength and disintegration, brittleness and strength, and a rosy, metallic kind of beauty.

I'm walking the museum once more, through the Ironwork Gallery with its stark black tracings and its view over the Fashion Gallery, thinking how oxides also warmed the wools and cottons of the garments displayed below, and the way we used to hand-patch cloth to the bodies of men and women, and how, unlike fabric, the mosaic receives no imprint from my quick-step mornings and late-night leavings, and how its oxide reds and greens are impervious, fixed, unfading; they cannot corrode.

I've found the answer to the mystery, the modest word, for it was Jesse Rüst, manufacturer of vitreous mosaic, who pieced his name there in 1875, because he took pride in his work. I think back to the roof and the rain and the footsteps my father took over its slippery surface, and how hard he tried to educate me, and how he kept a file with all my clippings, visited every exhibition I did, agreed with me that it was my *duty* to do it well. The same rusty sun that gave him balm made my existence possible too. I watch it set over the rooftops, fill the galleries with evening light.

DRAW THE CURTAINS

The cherry tree's optimism in continuing to flower in profusion out of all proportion to its scale and age, so that at its most flamboyant the branches are draped entirely with pink garlands, is touching. The drooping blossoms – for it is a small weeping cherry, not even as tall as me – are confetti between my fingers and no candidate for a flower arrangement; the moment the frail blooms are picked they begin to wilt and last barely a moment in the vase. Towards the end of this bravura display the blossom browns and drops and green pips emerge, notional cherries that never amount to much, and are stripped by the birds anyway. The rest of the year the tree is barely noticeable, as dock leaves and couch grass swathe the ground, and it becomes subsumed into the greening of a garden gone to seed.

The prunus was a gift that we replanted several times, each committal causing it to falter, and then rally. It was an offering to remember our son by, as if we would ever forget, but the flowering has always been too late, coming as it does a month after the anniversary of his death, as if in delayed shock. We had meant to buy another, to pinpoint that exact moment – for it had been the equinox, when the earth hangs on its pivot and momentarily day and night are perfectly equal. One of only two days in the year; a winter growing him, a spring and many more mourning him. But now it's been so long that the seasons

blur, and the branches of the tree are cracked and bent, and we know we won't get round to it, just as we have never got round to placing a headstone on his grave, for the words won't come. Anyway, the tree has done its dues. It asks nothing, but is always there, just as my imagined mothering is always present, sustained by what-ifs, if-onlys and what would life be like now, a conversation that cannot be had anything other than internally; eternally.

Lingering by the window, as the leaves damp down their greenness and a blackbird abruptly sings out against the closing of the light, as one did at the graveside, I think of Emily Dickinson's words of outrage, *a Bird/Defrauded of its Song*, and the irreconcilability of birth and death being as one, and the fused words that so concisely state their case: stillborn (first used in 1593 – perhaps before then it wasn't worth commenting on). It's been a three-decade goodbye, the cargo of grief abutting joy, the compilation and counting of objects, the mosaic of words and thoughts, the arranging of pebbles around my pond; the lost scent of flowers, the threads between places, the love of children, my long-time friend, the light-filled rooms, the garden at dusk, the quiet archives, my bridge and my river, the end of one story and the beginning of another; a patch-work life, perhaps.

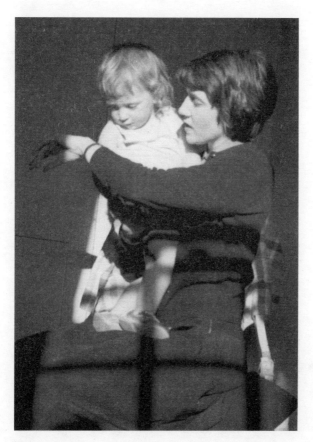

Time, 1956

ACKNOWLEDGEMENTS

To Julian Stair, thank you for the years and for believing in me; to Rose and Hattie, for being your wondrous selves; to Mark Wilcox for shared memory. To Gail Sulkes for her wisdom and Tim Marklew for his quiet support. To Mog Scott-Stewart, my guide through the shadows and into the light. To Syd and Jean Wilcox; did you get the letter I hid in the garden? I miss you every day.

To my dear friends who may or may not know they are in this book: Rob Barnard, Val Cole, Chas Collins, Simone ten Hompel, Rosemarie Jäger, Stephen and Juliet Lunn, Rod and Jane Tootell, Mark Sinclair. And to those who urged me on: Jill Coleman, Nicola Davies, Natasha Kerr, Lucy Maddox, Hugh Taylor and Sue Williams.

To the NHS, especially Dr Mark Layton and Kings College Hospital; to North Norfolk, and its soaring, healing skies; to Dr John Macleod and the Island of North Uist.

To my V&A colleagues, past and present: Christopher Breward, Tristram Hunt, Mark Jones, Tim Reeve, Christopher Wilk and Tom Windross, and the wonderful women I have worked with and admired over the years: Gannit Ankori, Kate Bethune, Clare Browne, Judith Clark, Oriole Cullen, Edwina Ehrman, Amy de la Haye, Joanne Hackett, Frances Hartog, Circe Henestrosa, Anna Jackson, Rachel Lee, Santina Levy, Jenny Lister, Linda Lloyd Jones, Eleri Lynn, Rosalind McEver, Valerie Mendes, Lesley Miller, Jo Norman and Sonnet Stanfill. To the London College of Fashion, Frances Corner and Jane Harris,

for giving me time, and to all the designers, artists and makers who enrich our lives.

To Arvon for its log fires and its libraries, and the poets I found there, especially Kate Clanchy, Richard Meier, Luke Kennard and Colette Bryce.

To Irvine Welsh who insisted I get in touch with the incomparable David Godwin, my touchstone, confidante and mentor over the last 5 years who always said, 'send more'.

To Alexandra Pringle for your absolute dedication to *Patch Work* and my absolute good fortune in you taking me on, to Lauren Whybrow for conjuring this book into being while reading Wordsworth, to Allegra Le Fanu, Anna Massardi, Kate Johnson for their calm guidance, to Alexis Kirschbaum and Marigold Atkey for that first encounter, and to Emma Ewbank for this beautiful cover.

In memory of Francis.

IMAGES

Photographs by Julian Stair unless otherwise stated

p. 8
Sheet
Linen
Late 19th century
France

p. 13
Camping
1959
Cornwall
Photo, Sydney Wilcox

p. 20
Purse
Embroidered cotton
Date unknown
Herat, Afghanistan

p. 27
Margaret Jean Wilcox
c. 1950
London
Photographer unknown

p. 32–3
The Vernal Equinox
*Monthly Changes of
Japanese Street-Scenes*
Paper and linen
Published by
T. Hasegawa, Tokyo
1903
Japan

p. 50
Border
Bobbin lace
Linen
18th century
Italy

p. 66
Purse
Silver
1909
Birmingham

p. 71
Making a collar support
1983
Victoria & Albert
Museum
London
Photo, Avril Hart

p. 76
Patchwork (detail)
Printed cotton
19th century
England

p. 86
Chatelaine
Silver
c. 1910

p. 92
Cabinet card
M. Sauvy of Paris
1886–93
Manchester

p. 98–9
Watch chain
Silver
c. 1890

p. 107
Rose and Hattie
1995
Brixton, London

p. 112
Shoes
Leather
Start-rite
c. 1996

p. 124
'Jackpot' jacket
Polyester
PLEATS PLEASE
ISSEY MIYAKE
AW 2010
Japan

p. 134
Corset cover (detail)
Cotton and lace
c. 1910
England

p. 151
Victoria & Albert
Museum
2007
London
Photo, Chris Floyd

p. 154
Flounce
Machine-embroidered
cotton
20th century
Switzerland

p. 158
Childhood home
c. 1960
West London
Photo, Sydney Wilcox

p. 160
Morris Oxford
1960s
Somewhere in Europe
Photo, Sydney Wilcox

p. 163
Expecting me
1954
Hyde Park Corner,
London
Photographer unknown

p. 168–9
Clock-winding keys
Brass and steel
19th century

p. 178
Buttons
Mother-of-pearl
1900–1950

p. 196
Shirt (detail)
Alexander McQueen
Silk damask
2015
Italy

p. 206–7
Herring dish
Wedgwood
Queen's ware
Earthenware
1780–82
England

p. 218–9
Ordnance Survey map
(detail)
South Kensington
Paper on linen
1869
England

p. 228
Saucer
Porcelain with blue
underglaze
1751
Jingdezhen, China

p. 240
Dress fabric (detail)
Silk brocade
Late 18th century
England

p. 252
Solanum jasminoides
2020
East Dulwich, London

p. 267
My mother and me
1956
Pimlico, London
Photo, Sydney Wilcox

ABOUT THE AUTHOR

Claire Wilcox has been Senior Curator of Fashion at the V&A since 2004, where she has curated exhibitions including *Radical Fashion, The Art and Craft of Gianni Versace, Vivienne Westwood, The Golden Age of Couture: Paris and London 1947–1957, Alexander McQueen: Savage Beauty*, and, with Circe Henestrosa, *Frida Kahlo: Making Her Self Up*, and instigated Fashion in Motion (live catwalk events in the museum) in 1999. She is Professor in Fashion Curation at the London College of Fashion and is on the editorial board of *Fashion Theory: The Journal of Dress, Body & Culture*. She lives in South London.